Promoted to Glory:

The Apotheosis of George Washington

Lenders to the Exhibition

James Abbe, Jr.
American Antiquarian Society, Worcester, Massachusetts
Art Department, Brown University, Providence, Rhode Island
Daughters of the American Revolution Museum, Washington, D.C.
Fraunces Tavern Museum, Sons of the Revolution in the State of
 New York, New York City
Historical Society of Pennsylvania, Philadelphia, Pennsylvania
Marblehead Historical Society, Marblehead, Massachusetts
Mead Art Museum, Amherst College, Amherst, Massachusetts
Metropolitan Museum of Art, New York City
Museum of the American China Trade, Milton, Massachusetts
National Collection of Fine Arts, Smithsonian Institution,
 Washington, D.C.
National Portrait Gallery, Smithsonian Institution, Washington, D.C.
The Newark Museum, Newark, New Jersey
New York Historical Society, New York City
New York Public Library, New York City
New York State Historical Association, Cooperstown, New York
North Carolina Museum of History, Raleigh, North Carolina
Old Sturbridge Village, Sturbridge, Massachusetts
Stanley Deforest Scott
Smith College Museum of Art, Northampton, Massachusetts

Promoted to Glory:

The Apotheosis of George Washington

Exhibition and Catalogue Prepared by
PATRICIA A. ANDERSON

Smith College Museum of Art
Northampton, Massachusetts

February 22 – April 6, 1980

Published by the Smith College Museum of Art,
Northampton, Massachusetts

Printed in the United States of America by
The Pioneer Valley Printing Company,
Easthampton, Massachusetts

Cover: Chinese, for the American Market
 Apotheosis of Washington. Early 19th century
 Reverse painting on glass
 Museum of the American China Trade, Milton, Massachusetts
 Catalogue number 2

Acknowledgments

Within a year of the founding of Smith, George Washington's Birthday took on special significance for the College. Rally Day, a College holiday, celebrated on February 22, has for nearly 100 years been given over to awards and speeches. In the past, it was a time for undergraduates to reflect on the ideals and courage of the founding fathers of our country. At one time such celebrations occurred throughout this country for even in mid-19th century the memory of Washington was vivid. People still lived whose parents and grandparents had seen or even knew George Washington.

Within the subsequent 130 years, the actual personality of George Washington has become so remote that in an age not notable for worshipful attitudes toward the heroes of the past or even toward the past itself, Washington is thought of only as a symbol. So complete has been the canonization of the man that the process which turned the human being into the Jove-like personage we think of takes on a special interest.

Patricia A. Anderson, who is a curatorial member of our staff as an intern subvented by the National Endowment for the Arts, arrived in Northampton with the idea of this exhibition nearly formed. Her master's thesis for the University of Michigan discusses the phenomenon of the deification of Washington and traces its progress through prints, paintings, sculptures, textiles and ceramics. This exhibition, built on her research, has been entirely her responsibility. She has not only conceived and organized it but has attended to every practical detail. In her work she received help and advice from Betty Monkman, Registrar of The White House; from David Sellin, Curator, United States Capitol; from Elizabeth Harris, Curator of Graphic Arts, and Herbert Collins, Curator, Department of Political History, the National Museum of History and Technology, the Smithsonian Institution, Washington, D.C. Harrison H. Symmes, Director, Ellen McCallister, Librarian, and Nancy Emison, Assistant Curator, the Mount Vernon Ladies Association of the Union, provided information and eased opportunities for study. Professor Irma Jaffe of Fordham University made available research on the work of John Trumbull while Davida Deutsch of New York City shared information about theatrical productions in Washington's memory. Many thanks are owed to Louis Tucker, Director, and Ross Urquhart, Curator of Graphic Arts, of the Massachusetts Historical Society as well as to Robert Vose of the Vose Galleries, Boston, Massachusetts.

Finally, David Huntington, Mrs. Anderson's thesis adviser whom Smith College lost some years ago to the University of Michigan, has generously offered advice. Lastly, we thank Sarah Ulen, formerly Registrar of this Museum and now Registrar of the University of Indiana Museum of Art, Linda Muehlig, Curatorial Assistant, and Judith Guston '82, a Smith undergraduate, who has been unusually helpful in countless ways.

Charles Chetham

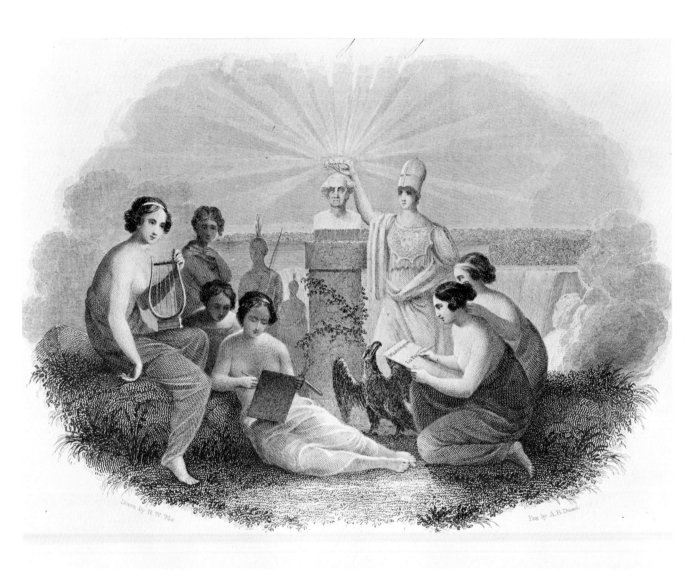

Drawn by R. W. Weir. Eng. by A. B. Durand.

16

Promoted to Glory:

The Apotheosis of George Washington

WASHINGTON! — a seeming emanation of the deity, charged with the salvation of his country! Who but an infidel does not see the hand of heaven, in raising up and qualifying a WASHINGTON for the several important stations he so ably filled?

So cried a pious nationalist addressing the brethren of a Charleston, South Carolina church on Independence Day, 1806. Already by that date, two generations of Americans had been charged from pulpits in every church across the new country to rejoice unto the agent of the divine, the immortal George Washington (1732–99); the exhortations would continue with undiminished zeal throughout the nineteenth century. For, in Washington's glorious service to the United States, Americans beheld a sight of grace: the hero's commission from on high to bring an end to war, to deliver a nation from the thralldom of tyrannical evil, and to stand as a symbol of liberty for the entire world to contemplate.

A keen sense of the heroic fired the thoughts of such Independence Day celebrants for decades after their hero's death. American nationalists steeped in biblical and ancient histories had just emerged from a fight for autonomy which had revealed patriots' exploits as sublime as those in the epics of Homer, Plutarch, or the Old Testament. Their immediate artistic and literary legacy was that of eighteenth-century idealists who invoked glories of the past to establish an ancient pedigree for the revolutionary spirit which characterized the closing decades of that era. The burgeoning republican culture derived form and content from the European Grand Manner and thereby aligned its art and literature with noble themes and commanding presentations of antiquity, the Renaissance, and the Baroque. Its preoccupation was ever and enthusiastically America, nonetheless, and the country's artists and men of letters held fast to an ideological foundation which rose from their own soil. In portraying heroes, they drew more readily upon a heritage of Puritan forebears who regarded New World inhabitants as the embodiment of sainthood, representatives of a new chosen people. Nationalists invoked the name of their supreme commander and first President as evidence of and justification for a perceived American mission that would, they believed, ever prevail. In committing to legend Washington's successive acts of patriotism and attributes of virtue, the people created an emblem of all that was noble in the American character, a process of self-examination which one contemporary historian has called "a cultural apotheosis in which that nation can see an image of its best aims."[2]

That Americans should apotheosize Washington in art, literature, and oratory in the late eighteenth century and throughout the nineteenth century was an ineluctable product of regenerate society. Self-celebrating imagination sought in the arts forms that would articulate the spirit of the age—images that would elevate secular issues to the level of the sacred for a populace which saw a vital link between religion and liberty. Thus, Americans embraced ambitious public spectacles, history pictures, portraits, and emblematic devices—or verbal counterparts in oratory, biography, and epic poetry—as grandiloquent means to convey symbolic interpretation of their identity and their venture. In each medium, Washington proved a more than fitting subject. His patriotic deeds were the material of rhetoric while his awesome stature and countenance and his ethical probity provided a standard of human perfection. "Such was Washington: a combination of form where every grace and virtue appeared to have set an indelible seal," declared one patriot. But the hero could only embody, by extension, the spirit of the nation, become the personification of an entire community of the elect, as on the New World stage he reenacted the miracle of Nehemiah.[4] Allegorical representations of Washington derived from both his capacity to signify the more exalted American mission and from firm belief in the New World's singular ability to give rise to such a hero and reveal the amplitude of his glorious life. America's past and prophecy constitute the signal truths of Washington's apotheosis, and popular depictions of the man as saviour or demigod register in large measure the Puritan ideological origins of American culture.

To appreciate America's appetite for indulging in images of a godlike Washington, one must understand the ever-popular vision of the New World as a prophetic second Israel and the pervasive conception of its inhabitants as latter-day saints. Founded in scripture, these reciprocal Puritan beliefs provided a framework for American nationalism. Beginning in the seventeenth century, writers of colonial histories expatiated on the promised land discerned to the west of a corrupt Old World, analogous to Jerusalem that itself lay westward of Babylon. Forebears escaped from "the worse than Egyptian bondage of Great Britain."[5] Migration constituted not only release but rebirth, and the transatlantic crossing was typically equated with baptism and conversion in New England autobiographies. One bound for the New World recorded in his diary that he followed "the Lord departing from England . . . to come over, to live among God's people as one come out from the dead."[6] Once set upon heaven, settlers realized prosperity in the New World which could only have been providential. Another colonist typically extolled:

> Look upon [our] townes and fields, look upon [our] habitations and shops and ships, and behold [our] numerous prosperity and great increase in the blessings of *Land and Sea*. . . . Yea, there is not only a spiritual glory, visible only to a spiritual eye, but also an externall and visible glory. . . . And, indeed, if we cast up the account and lay all things together, God hath been doing the same thing here that is prophesied of Jacobs' remnant. . . . He that hath said; *I will make the Wilderness a Pool of Water, and in the dry lands I will plant a Cedar*, hath fulfilled the word before our eyes. And we may conclude that he intended some great thing when he planted these Heavens, and laid the foundations of this Earth. And what should that be if not a *Scripture-Pattern* that shall in due time be accomplished in the whole world throughout.[7]

Clearly the Puritan theocracy exhorted their countrymen to see America in scripture in order fully to understand their environment and their individual roles within it. All orders were given by God to the end that the New Israelites might be the people of the covenant. No false distinctions were made between the sacred and the secular. Migration, settlement, theocracy, and pelf were the work of Providence. As intellectual historian Sacvan Bercovitch has demonstrated, the persistence of Puritan dogma in American culture cannot be understated.[8] It provided sufficient justification for the task of nationhood and held, therefore, great appeal for the first century of American nationalists. Revolutionaries, for example, could discern God's hand in the most unlikely places without regard for logic, as did the composer of this verse on the miraculous birth of a nation at the hands of God's attendants:

> When pregnant nature strove relief to gain
> Her *nurse* was Washington, her *midwife* Paine;
> The infant Independence scarce began
> To be, e're he ripened into man;
> France his *god father*, Britain was his *rod*,
> *Congress* his *guardian*, and his father GOD.[9]

Americans could likewise extrapolate from Puritan doctrine to derive the concepts of manifest destiny and the American Way. They could put the god of Ezekiel's vision on the country's earliest bank notes[10] and compare Washington to Moses.[11] Nationalists spurred sales of Cotton Mather's spiritual biographies, *Magnalia*, as late as 1853 because, one librarian speculated, they wished to recount the favor of heaven, to "look with amazement on a great country . . . more extensive than Rome . . . a great population . . . all looking for salvation in the name of the DIVINE NAZARENE."[12] Harriet Beecher Stowe acknowledged the impact of Mather's volumes when, writing at mid-century, she reflected:

> What wonderful stories these! Stories, too, about my own country. Stories that made me feel the very ground I trod on to be consecrated by some special dealing of God's providence. . . . The heroic element was strong in me, having come down by ordinary generation from a long line of Puritan ancestry.[13]

That most Americans in the eighteenth and nineteenth centuries shared Stowe's attitude toward history—no matter how far they were removed from original Puritan dogma—is significant. Ours was a populace which could easily accept—indeed, could mandate—portraits of Washington as a heavenly agent; and like it or not, it was this public from which American and immigrant artists, regardless of religious persuasion, were required to seek support.

Since to see God as omnipresent in the New World was a sign of the progress of the Puritan's soul and evidence of his own divine election, biographers long before Washington's day recognized godlike qualities in American leaders whom they proceeded to apotheosize for the edification of the public at large. Spiritual biographies provide, therefore, a characteristic, though not unique American precedent for the transfiguration of Washington in art and literature. They help to explain, too, in some measure, the public's receptivity to portraits of allegorical and metaphorical nature. Bercovitch has analyzed the process by which the individual became the most coherent conveyance for linking allegory and history; he coins the term "anthropomorphic

nationalism" to place proper stress on the all-important human element on which dogmatic concerns of personal election, national election, and prophetic vision converged.[15] Outward signs divulged an individual's inner beliefs, so military and civic leaders or church divines offered self-justifying Puritan chroniclers a wealth of revealing events from which to abstract their divinity. Justice Samuel Sewall, for example, canonized Samuel Willard when he declared:

> As *Joseph* let his Brethren see
> *Simeon* both alive and free;
> So JESUS brings forth *Samuel*;[16]

That God promises to raise up heroes to protect his people is further attested in Edward Johnson's poetic tribute to another heaven-sent leader, Thomas Dudley, first major General of Colonial military forces. Of Dudley's commission from the Lord, Johnson wrote:

> To trembling age, thou valiant sage, one foot will not give ground,
> Christ's Enemies from thy face flies, his truth thou savest sound.
> Thy lengthened days to Christ's praise, continued are by him;
> To set by thee, his people free, from foes that raging bin.[17]

When Benjamin Thompson eulogized colonial Governor John Leverett, he projected:

> This will be the omen of your future peace
> Heaven will create or rayse up more of these.[18]

Thompson thus assured his readers of the continuity of the covenant by establishing a long line of heaven-sent leaders. Indeed, Washington was but Thompson's prophecy borne out. Providence selected the Revolutionary War as the time and place for divine intercession and gave the American colonies, in Washington, an agent of God to serve the heavenly cause of liberty at its most desperate hour. An aide to the General described the saving grace:

> . . . Now darkness gather'd round;
> The thunder rumbled and the tempest frown'd;
> When lo! to guide us thro the storm of war,
> Beam's the bright splendor of Virginia's star.
> O first of heroes, fav'rite of the skies,
> To what dread toils thy country bade thee rise!
> "Oh rais'd by heaven to save th'invaded state!"
> (So spake the sage long since thy future fate)
> 'Twas thine to change the sweetest scenes of life
> For public cares—to guide th'embattled strife.[19]

Drawing upon an extensive hagiography of seventeenth- and eighteenth-century American saints, panegyrists had available a ready foundation upon which to build an image of a sacred Washington. By construing a demigod from the litany of Washington's heroic deeds, writers and orators, in effect, joined an established company of national seers who were resolved to link the hero with the divinity, invest secular events with religious significance, and thereby assert God's enduring sanction of America's mission.

Because nationalists believed America and its destiny "is to be seen fairly recorded in Scriptures,"[20] it is not surprising to find Washington most frequently compared with the divinely inspired Moses in popular literature and oratory;[21] and if Washington was predestined to be America's Moses in life, then what was his due but a glorious death and the transfiguration of the man into the divine spirit. One study has revealed that the most commonly cited texts in Washington eulogies

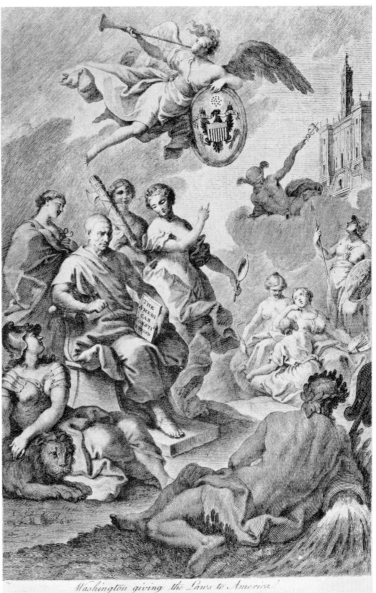

19 *Washington giving the Laws to America.*

are those verses from the final chapter of Deuteronomy which describe the death of the Hebrew deliverer, who ascends Mount Nebo to die in the company of his Lord.[22] "The American Leader also ascended the mount [Mount Vernon] to die," indeed in even greater glory than Moses, according to at least one eulogizer: Washington, "while yielding his breath . . . saw his country's glory finished. The former dies on a mount of vision and hope, but the other on a mount of possession and enjoyment."[23]

Americans accepted the similarities of Washington and Moses at death since the parallels of the two lives were firmly established. Robert Hay, in an analysis of the imagery of Washington funeral elegies, has noted that the Washington as Moses theme found sub-

stance in even the most superficial details of each leader's life and work. In the American mind Moses and Washington had, for example, the same spiritual origins. God had commissioned each man to deliver his people, the chosen people, from oppression in accordance with a divine plan. As orators were quick to point out, "Kind Heaven, pitying the servile condition of our American Israel, gave us a second Moses, who should, (under God) be our future deliverer from the bondage and tyranny of haughty Britain."[24] To further the analogy, similarities were drawn in their early lives: in the providential migration of each deliverer's forebears to their respective new lands in which their offspring would one day be needed; in the like nurturing of each youth through the care of Providence and motherly love; and in their training as warriors. Americans were preoccupied, however, with the profounder similarities in the means and successful efforts of Moses and Washington to free their respective peoples from oppression. "Moses led the Israelites through the red sea: has not Washington conducted Americans through seas of blood?"[25] asked another eulogizer. Finally, both men had been law givers—Moses, when he received the commandments at Sinai and left to his people the book of Deuteronomy; Washington, when, as an engraving by J. P. Elven illustrates (19) he presided at the Constitutional Convention in 1787 and gave the country, ten years later, a doctrine of federalist dogma, his Farewell Address. One mid-nineteenth century clergyman, the Reverend Hollis Read, summed up the preoccupation of the age when he wrote in *The Hand of God in History:* "Moses was the George Washington of the Jewish Commonwealth."[26] That Moses was the controlling parallel in popular literature on Washington as military commander and President testifies to the religious zeal that characterized American nationalism and the extreme reverence accorded the Father of his Country.

The American tradition of apotheosizing heroes was, however, a written one. The country's visual arts of the eighteenth and nineteenth centuries lack, for the most part, such obvious religiosity, a curious fact since popular literature reveals the extent to which religious principle influenced all human activity in Protestant America. That an appetite for portraiture did certainly exist during the formative years of the new nation, nevertheless, argues that art, too, was invested with religious meaning.[27] Evidence might be seen in the number of portraits of members of the mercantile class throughout the eighteenth century. As commerce was respected as a promoter of inquiry, a means to advance liberty, and an agent for manifesting God-given wealth in the New World, the merchant enjoyed near apotheosis in the arts.[28] He had a role in the order of America and became an exemplar of her illustrious past and prosperous future. It is this belief in divine order rather than a concern with churchly matters which characterized religion in America and which thus constitutes the religious impulse in her fine arts. Civic, military, and church leaders could all correspond to scripture's saints and seers because of their principal roles in America's prophetic history. In portraits of these individuals, it was the image of the *type* rather than the artistic endeavor itself which won respect in the new nation. Sitters' names are frequently recorded for posterity

while artists' identities remain anonymous. Portraits, therefore, sprang inevitably from an abiding emphasis on the individual's function in the country's sacred past and prophecy.

Portraits of Washington are part and parcel of the religious and historical preoccupation which characterizes the period from 1776 to 1876. The nation's early obsession with his unparalled military success continued after Washington had risen to the position of highest civil authority. To Americans, his achievements were real, familiar, and numerous; they needed only to speak for themselves in artistic compositions which rendered significant moments of contemporary history intelligible. His actions revealed his sainthood. The Father of his Country could be presented as an active agent in carefully defined situations which he controlled and apotheosis was underway. John Trumbull's (1756–1843) *General Washington Before the Battle of Trenton* (7) and Valentine Green's (1739–1813) *General Washington* (20), after Charles Willson Peale (1749–1827) (fig. 2), portrayed prior to the battle of Princeton, are examples of narrative and affecting portraits in which the hero is abstracted from, but derives his significance because of, the historical context. In each of these portraits, the viewer confronts an idealized, full-length, frontal image of the man but easily discerns the specific background event. By means of their judiciously chosen form and carefully ordered compositions, such portraits could establish a bond between Washington and the American citizen. Thus there came into being a social framework, evolving from the *exemplum virtutis* of Puritan spiritual biography, for the nationalistic observer was easily moved by what he saw.

The histrionic character of American portraits endowed them with a literal immediacy easily assimilated by a citizenry steeped in history. Portraitists, like the new nation's historians, had faith in the efficacy and importance of the work of art to influence the affairs of their countrymen. In this regard, they resemble the sculptors of declamatory monuments in ancient Rome and the French democrats of the eighteenth century, for whom commemorative art became a form of propaganda. Like their ancient and contemporary prototypes, monuments to Washington—prints and paintings as well as sculpture and architecture—were intended to be seen by many, to be clearly understandable, and, hence, to be models of human behavior. Moreover, such portraits were designed to be honored in themselves as icons for a providential national mission and as assurance of the continuity of America's covenant. Thus portraits of Washington could make sacred the secular. Therein lies the religious nature of one of the country's predominant art forms.

Perhaps because ancient Rome and revolutionary France exercised close supervision of the arts for propagandistic purposes, egalitarian Americans drew not directly from these examples in assessing the role of art in a republic. Rather, they found artistic principles befitting their spiritual needs in the prescriptions of eighteenth-century English aestheticians. The *Discourses* of Royal Academy President Sir Joshua Reynolds (1723–92) and the teaching of his colleague, expatriate American artist Benjamin West (1738–1820), furnished theory for a systematic linking of form and spiritual concerns. Through the first two decades of the nineteenth century, the new nation's painters flocked to West's London studio. Volumes of the *Discourses* were awarded to

outstanding students of America's own newly-established art academies as late as 1826.[29] Together West and Reynolds offered examples of the painter's successful efforts to instruct his public and elevate popular taste. More importantly, however, they offered moral insights into their art and made philosophers of its practitioners.

In addition to pedagogic practicalities, Reynoldsian theory justified art's moral function far beyond its service to momentary pleasures. Universal truth, inherent in all natural forms, was the subject of Reynolds' art, and his teaching resounded with conviction:

> This is the idea which has acquired, and which seems to have a right to the epithet of *divine*; as it may be said to preside, like a supreme judge, over all the productions of nature; appearing to be possessed of the will and intention of the Creator, as far as they regard the externall form of living beings. When a man once possesses this idea in its perfection, there is no danger, but that he will be sufficiently warmed by it himself, and be able to warm and ravish every one else.[30]

If all nature's forms possessed general truths which a painter might discover and define, it followed that universal virtues could be made implicit in portraits of heroes. Benjamin West firmly believed this. In a letter to Philadelphia painter and friend Charles Willson Peale in 1809, West wrote:

> The art of painting has powers to dignify man, by transmitting to posterity his noble actions and his mental powers to be reviewed in those invaluable lessons of religion, love of country, and morality.[31]

West was actually advocating a turn to history pictures away from "the indiscriminate waste of genius in portrait painting."[32] Yet such exalted themes as "religion," "love of country," and "morality" could conjure up heroic portraits in Protestant America, for these were the very virtues of individual Christian good. West's instructions were not unlike exhortations from the pulpit. Such principles served well a populace of pious nationalists who justified art's place in their culture on moral, ethical, and theological grounds. Behind depictions of an apotheosized Washington, therefore, lay efforts to impose the principles of eighteenth century art theory upon American portraiture in order to define ideal, and hence, spiritual form.

West and Reynolds insisted that to study antique sculpture was to learn the nexus of form and virtue. When West advised pupils "to make from the Apollo . . . a general measurement or standard for man . . .,"[33] he expected them to derive both a mathematical system of proportion and a quality of mind. His followers came to know the Greek statue's form instinctively through assiduous copying from plaster casts and engraved illustrations in widely-popular volumes on antiquities. Having, therefore, trained eye and mind, Americans and Europeans could easily see in Washington the stature and virtue of the *Apollo Belvedere*, thereby fusing man and god. A French compatriot, the Marquis de Chastellux, described the Olympian dimensions of General Washington thus:

> If you are presented with medals of Caesar, or Trajan, or Alexander, in examining their features, you will still be led to ask what was their stature, and the form of their persons; but if you discover, in a heap of ruins, the head or the limb of an antique *Apollo*, be not curious about the other parts, but rest assured that they were all conformable to those of a God. Let not this comparison be attributed to enthusiasm! It is not my intention to exaggerate. I wish only to express the impression General Washington

has left on my mind; the idea of a perfect whole, that cannot be the product of enthusiasm. . . .[34]

That the Marquis' impression differs considerably from an early, and therefore objective view of Washington reveals both the effect of enthusiasm and the extent of the classicizing tendency upon depictions of Washington. Previously, General George Mercer wrote of a twenty-eight-year-old Washington who had distinguished himself in the French and Indian War:

He may be described as being straight as an Indian, measuring six feet two inches in his stockings and weighing 175 pounds. His frame is padded with well-developed muscles, indicating great strength. His bones and joints are large, as are his feet and hands. He is wide-shouldered, but has not a deep or round chest; is neat waisted, but is broad across the hips, and has rather long legs and arms.[35]

Figure 1. *Apollo Belvedere* from Johann Joachim Winckelmann, *Histoire de l'art chez les anciens* . . . (Paris, Chez H. J. Jansen et compe., 1790–1803), I, Pl. XXV. John Hay Library, Brown University.

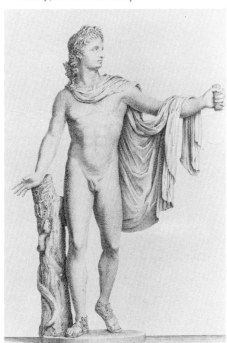

7

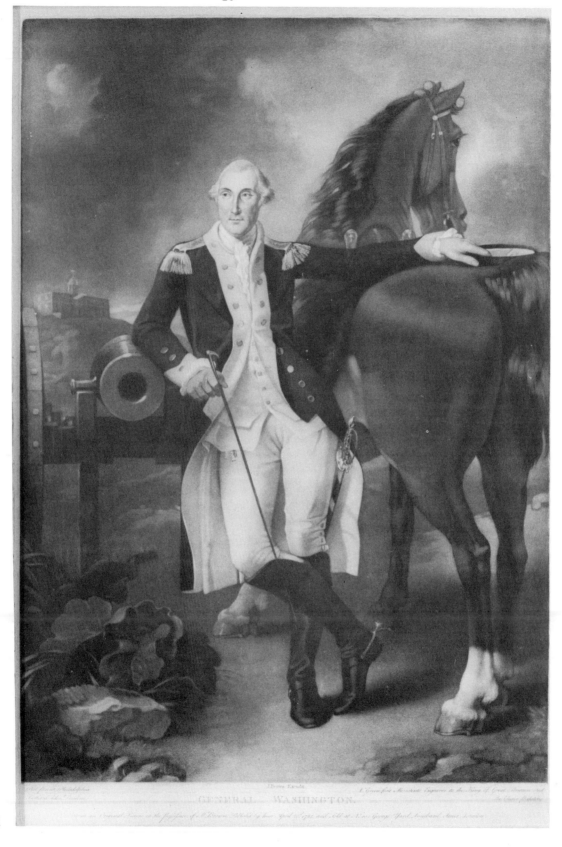

GENERAL WASHINGTON.

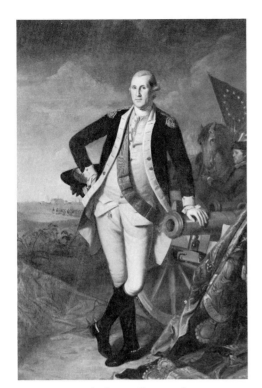

Figure 2. Charles Willson Peale, *George Washington at Princeton*, 1779; oil on canvas. Pennsylvania Academy of the Fine Arts. Gift of the Executors of the Elizabeth Wharton McKean Estate.

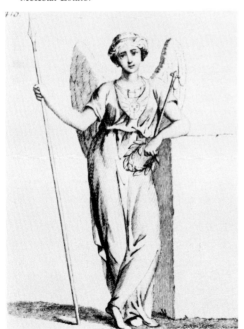

Figure 3. *Virtue* from George Richardson, *Iconology; Or a Collection of Emblematical Figures . . .* (London, 1779), Pl. 415. Vassar College Library.

Though he sketches a commanding countenance, indeed, Mercer does little to evoke the classical beauty delineated by the Marquis. Nationalists, however, were predisposed toward the de Chastellux image. Five years after the Marquis published his impression of the commander-in-chief, Colonel John Trumbull, himself a veteran of military service under Washington, painted *General Washington Before the Battle of Trenton* (7) in pose and stature recalling the *Apollo Belvedere* (fig. 1). Trumbull's own description of *General Washington Before the Battle of Trenton* indicates that he intended it as a transcendent portrait of the man and the event.[37]

In their efforts to define moral issues in aesthetic terms, artists of the eighteenth-century academic tradition could consult, in addition to casts and engravings after antiquities, a lexicon of personified virtues from which to draw models for anthropomorphized nationalism. The libraries of Reynolds, West, and the Royal Academy all contained George Richardson's 1779 edition of the ever-popular *Iconology* of Césare Ripa.[38] Ripa served as a sourcebook for artists of allegory from the time it first appeared at the end of the sixteenth century to the decline of the Rococo period, and its "four hundred and twenty-four remarkable Subjects, moral and instructive; in which are displayed the beauty of Virtue and deformity of Vice . . . with explanations from classical authorities . . ."[39] were particularly suited to aesthetic principles of the Enlightenment. The Richardson edition was dedicated to artists that they should:

> . . . present to the understanding and judgment of the spectator, something more than is offered to the external eye; and in this attempt he will succeed perfectly, if he knows the right use of allegory, and is dextrous enough to employ it as a transparent veil which rather *covers* than *conceals* his thoughts. He has chosen a subject susceptible of poetical expression—In such a case, his art will inspire him, and kindle in his soul the divine flame that Prometheus is said once to have brought by stealth from the celestial regions.[40]

The process of abstraction which Richardson—and Reynolds—advocated was more than art theory; it was a spiritual impulse, an exhortation to enlist divinely-inspired vision to create, through the veil of allegory, poetic images expressive of more than that apparent to the observer's eye. Allegory addressed itself to the mind and, hence, contemplation of the moral content within specific forms. Interestingly, Richardson in his preface points to two apotheoses in seventeenth- and eighteenth-century art as exemplary ventures into the sublime region of allegory: Peter Paul Rubens' *Apotheosis of James I* on the ceiling of the banqueting house at Whitehall, and François Le Moine's *Deification of Hercules*, designed as an allegory on Cardinal Fleury, at Versailles. American artists working at West's studio and at the Royal Academy must have known Richardson's profusely illustrated volumes as well as Reynolds' allegorical portraits after Ripan figures.[41] When Trumbull arrived in London in 1780, one year after publication of the *Iconology*, he painted from memory an early portrait of Washington (fig. 13) which closely resembles, in the figure's stance and context, Ripa's *Patriotism* (fig. 12), illustrated and described in Richardson. This Trumbull portrait was subsequently engraved by Valentine Green (20) and the mezzotint became an important medium for transferring the iconic image to allegorical textiles (37, 38). Green, a subscriber to the

1779 *Iconology*, engraved another transcendent image of Washington when he made a copy after Englishman Thomas Stothard's (1755–1834) version of Charles Willson Peale's life portrait of the General (21; fig. 2). Stothard altered the Peale portrait considerably. In contrast to the more upright Peale *Washington* leaning on a cannon to the right, the graceful Stothard figure rests easily upon a cannon at left. Such a dramatic change suggests that Stothard intended his figure to conform to the pose and attributes of Ripan *Virtue* (fig. 3). In popular literature on Americans in general, and General Washington in particular, the words "patriotism" and "virtue" predominate. On the importance of these specific notions in American prose, Howard Mumford Jones has stressed that "unless we comprehend that eighteenth century America cherished this ideal, we cannot understand the power of Greece and Rome in the Revolutionary Period."[42] Nor can we appreciate the extent to which artists entertained these emblematic forms in portraits of the supreme patriot and virtuous man.

Under the influence of Reynoldsian aesthetics, American portraitists became so successful in developing a repertoire of classical motifs from their *Pater Patriae* that they facilitated the wide use, in popular portraiture, of a vocabulary of forms which would distinguish the illustrious hero even though the context of the motifs was no longer American history. Overt associations with apotheosized leaders of ancient Rome, derived from illustrated books on Roman history and declamatory monuments, were easily made once Americans became accustomed to the forms of Neoclassicism. Togated and laureate Washingtons appeared within his lifetime and endured throughout the nineteenth century at all levels of artistic endeavor. One of the earliest examples of Washington's imperial apotheosis is the public display of respect for his Presidency. When Washington made his journey from Mount Vernon to New York for inauguration as the country's first

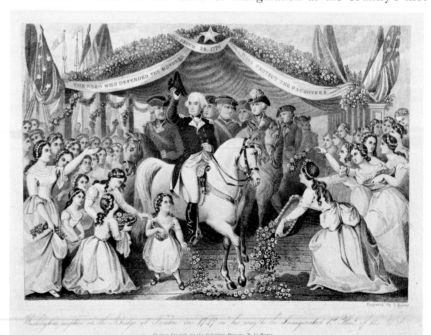

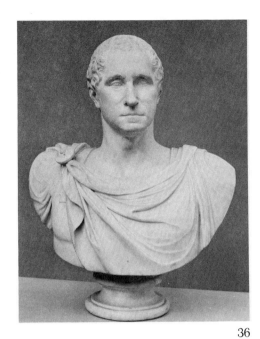

36

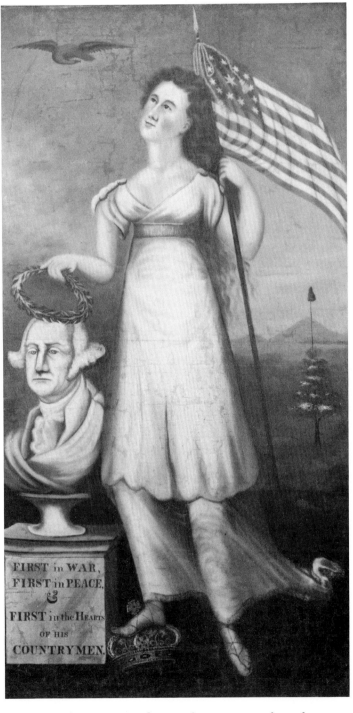

1

President in 1789, he was greeted at nearly every stop along the route by ceremony—grand triumphal arches and repeated crownings with wreathes of laurel. Some of America's leading artists were responsible for the grand ephemeral displays which, by the time of Washington's inauguration, had developed into a sophisticated art form. The

pageants are known today primarily through descriptions in newspapers, diaries, and poetry.[43] Thomas Kelly's (c. 1795–c. 1841) *Washington on the Bridge at Trenton* (24) is a rare illustration of the form and scale of these apotheoses. Another example of apotheosis is a portrait bust by Italian sculptor Giuseppe Ceracchi (1751–1802; 36), who came to the United States in 1790 and then returned in 1793 with plans to erect a monument to the American Revolution. Washington sat to him in 1791–92 and again in 1795, when this bust was made. Ceracchi idealized the aging Washington, at once conferring upon him the diadem of the Roman emperor and the heavenward aspect and nonspecific gaze of apotheosis common to imperial portraiture.[44] A less accomplished, but no less emphatic example of apotheosis in the Romanlike portrait bust is a painted windowshade, *Washington and Miss Liberty* (1), in which the crowning of *Pater Patriae* by the classical goddess is the culmination of the scene both visually and symbolically. American adaptation of the Roman idea of majesty is further evinced in an *Equestrian Washington* (fig. 4) attributed to John Vanderlyn (1775–1852). The mounted figure brandishing a sword compels association with the image of numinous power inherent in the gesticulating equestrian emperors of Roman monuments and coins.[45] In 1850, still another imperial apotheosis was presented in a painting by James Burns (active 1840–60), entitled *Washington Crowned by Equality, Fraternity, and Liberty.* Though Burns' canvas is now lost, an elabo-

Figure 4. Attributed to John Vanderlyn, *Equestrian Washington;* oil on canvas. Massachusetts Historical Society.

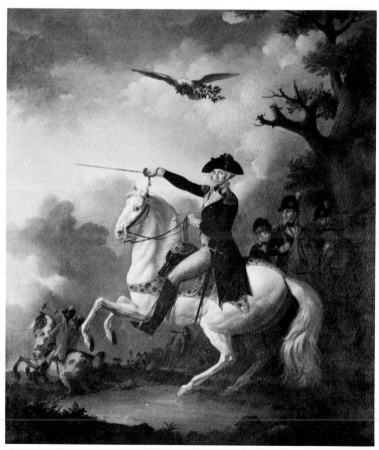

Figure 5 (facing). Constantino Brumidi, *The Apotheosis of George Washington;* fresco. United States Capitol, Washington, D.C.

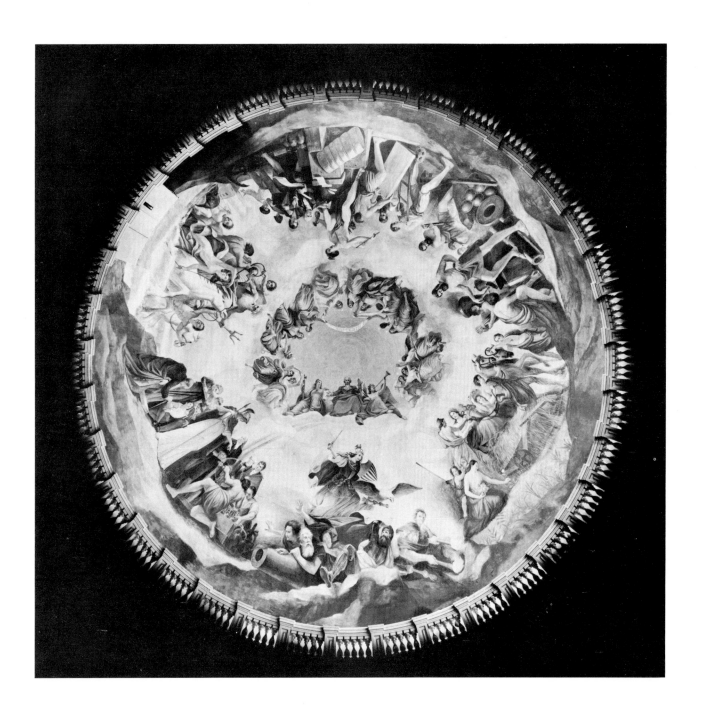

Figure 6. Horatio Greenough, *George Washington,* 1840; marble. National Collection of Fine Arts, Smithsonian Institution. Transfer from United States Capitol.

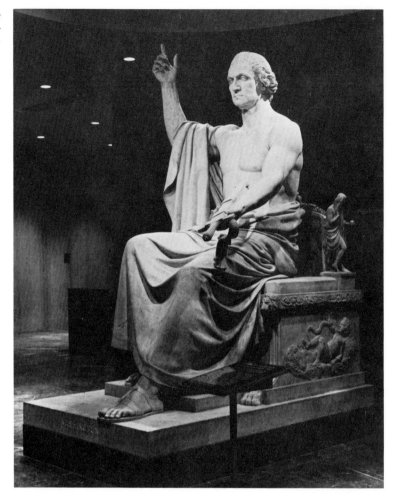

Figure 7. *Olympian Zeus* from Quatremere de Quincy, *Le Jupiter Olympian* (Paris, 1815), Pl. XVI. George Peabody Department, Enoch Pratt Free Library.

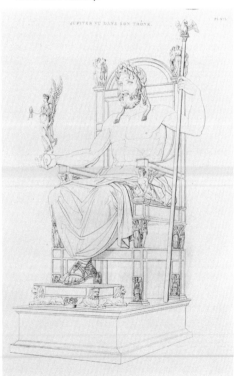

rate description of the laureate Washington survives in an address on the occasion of its exhibition at New York City's Apollo Club.[46] The most ambitious display of imperial majesty is perhaps that frescoed into the canopy of the United States Capitol dome (fig. 5). Executed by Italian painter Constantino Brumidi (1805–80) in 1861, the program includes Washington enthroned amid personifications of the peace and plenty yielded by liberty and nationhood and recalls the grand architectural embellishments proclaiming imperial apotheosis that graced, for example, the cosmic hall of Emperor Nero.

To the extent that such images of classical apotheosis glorified the country, Americans embraced these depictions of Washington. Just as they believed "the high order of families in Rome gained their importance from the exploits of their ancestors . . . exploits . . . perpetuated by statues,"[48] so Americans believed that their people should look to imperial images of Washington in majesty for edification and celebration of their own high moral estate.

Superficialities in classical images of apotheosis could be denigrated as easily as they were accepted, however. Imperial apotheosis also signified the elitism and paganism that corrupted fallen republics,

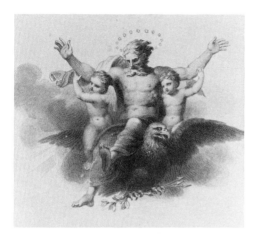

Figure 8. Asher Brown Durand, *Jove* (after Raphael, *Vision of Ezekiel);* engraving. National Museum of History and Technology, Smithsonian Institution.

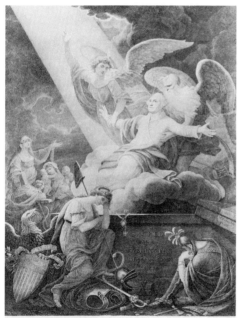

COMMEMORATION of WASHINGTON.

11

an association of which the new nation was only too keenly aware. For the most part, Americans demanded that classical ideals be translated into specifically New World types in order to intensify moral lessons innate in such images. The basis for America's self-laudatory taste was as much each citizen's "own eyes and untaught good sense,"[49] as it was an understanding of ideal form. When in 1841 sculptor Horatio Greenough (1805–52) unveiled his *Washington as Olympian Zeus* (fig. 6; 12), modeled on a reconstruction of the Phidian sculpture published by French antiquarian Quatremere de Quincy in 1815[50] (fig. 7), he confronted harsh ridicule. The monument's complex symbolism offended democrats who considered it flagrantly elitist. Moreover, a half-clad, togated Washington violated their leader's distinctly American identity. No wonder Greenough's masterpiece was damned and doomed. Novelist Nathanial Hawthorne, writing in 1858 at the high tide of Victorian sensibility, understood full well why his countrymen were unable to reconcile idealism and realism in this tribute to their hero:

> Did anybody ever see Washington nude? It is inconceivable. He had no nakedness, but I imagine he was born with his clothes on and made a stately bow on his first appearance in the world.[51]

Americans adopted classical prototypes for depictions of a godlike Washington within the hero's lifetime. Scenes of biblical apotheosis appeared with Washington's death in 1799. Yet, his ascent to heaven was effected primarily in the popular arts—in memorial prints and theatrical displays, for instance—and in compositions which freely combine Christian virtues and classical personifications. Thus there is indicated in such motifs an interest not so much in overt religiosity and specific concerns of American Protestantism as a will to present even grander allegories on national aims than classicizing the hero could afford. Such apotheoses of Washington frequently bring to mind ambitious Renaissance and Baroque designs of Christian majesty in which ascension is no less figural than it is literal—the result of highly compressed compositions propelling the divine spirit into a celestial realm along rising, dramatic diagonals culminating in bursts of effulgent light and color that signalize heaven. Moreover, American versions of biblical apotheosis effect associations of republican virtue with Christian good and thereby elevate national ideals of liberty and equality to the realm of sacred truths.

By aligning the expressly American image of Washington transfigured with religious art of the Old Masters, artists of the new nation could purport a relation to the likes of Raphael, Michelangelo, or Rubens. These men were particularly revered by painters in the academic tradition; and the American *cognoscenti*, in their pretensions at "good taste," made a point of being conversant with the Old Masters. Raphael's *Transfiguration* and the *Vision of Ezekiel* were held up to followers of Reynolds and West as two of art's finest examples of the union of beauty and universal truth—as works, therefore, to be imitated. Rubens' *Apotheosis of James I* was singled out as an exemplary, ennobling allegory by George Richardson in the *Iconology.* American artists, literate in their profession, heeded the precepts of such enlightened aestheticians and in memorials to Washington lit upon a suitable theme through which they could impart lessons learned from study of the great traditions.

The impact of that tradition is seen, for example, in a popular apotheosis of Washington designed and engraved by Irish immigrant artist of Philadelphia, John James Barralet (c. 1747–1815). Barralet's shrouded, semi-recumbent Washington rising from the tomb (11) bears a striking resemblance to the God of Ezekiel's vision with arms spread wide in a gesture of numinous power in Raphael's famous composition. Washington, too, is transported to heaven by attending virtues. Barralet's reference to Raphael is understandable since, through association with the Royal Academy from 1770 to 1776, the printmaker was well aware of academic theory. Reynolds in the *Discourses* referred to *The Vision of Ezekiel* as one of only three works approaching in magnificence Michelangelo's Sistine ceiling.[52] Napoleon had taken the painting from the Uffizi in Florence to Paris, where it graced the imperial collection from 1799 to 1814[53], during a period coinciding with mourning for Washington's death. Americans who traveled to Paris in those years surely knew the painting. Artists like Barralet, who never saw the French imperial treasures, knew engravings after Raphael's work. America's awareness of *The Vision of Ezekiel* is made evident by the fact that it was ultimately engraved for United States bank note vignettes by Asher Brown Durand some time after the first decade of the nineteenth century (fig. 8). Barralet's motif may be construed as both a tribute to his own aesthetic acumen and a memorial to Washington. Because Barralet's literate audience would doubtless have recognized the prototype, it readily sanctioned such an overtly religious statement about the Father of His Country. In the American mind, art rewarded virtue by invoking great art.

The image of Washington in heaven served a second function in addition to that of elevating art in the burgeoning new culture. The motif was, further, another means to securing a national religious experience which would spur the individual's love of country and foster a universal sense of common identity—an artistic bulwark, as it were, against disastrous consequences of want of national feeling among Americans. Like Puritan biographies and funeral elegies, memorials to Washington advance national as well as individual virtues. Classical personifications of Liberty and America, as well as the attributes of power, union, and industry, figure prominently in these displays of Christian majesty. The female Liberty occupies a central place in Barralet's *Commemoration of Washington*, which also employs such nationalistic devices as the American Indian and the eagle of the United States' official emblem. Similarly, Enoch Gridley's (active 1803–18) mourning picture (22) commemorates Liberty and the Revolutionary War battles of Trenton, Princeton, Monmouth, and Yorktown. Such nationalistic statements are indeed in keeping with the Puritan tradition of manifesting America's covenant through individual glory. Yet, in the first decades of the nineteenth century and again in the decade preceding the Civil War, the apotheosis of Washington in popular arts bore an immediate relation to current politics.[54] At the time of Washington's death, conservative Federalists believed that the United States faced direct threat from Napoleonic imperialism in Europe and that factious Jeffersonians within the country fostered disunion as well. They promoted the idea that God would keep their beloved second Israel and, having called home the divine American Moses, He would raise up an American Joshua in Washington's successor, John Adams. The glory of Washington was invoked repeatedly

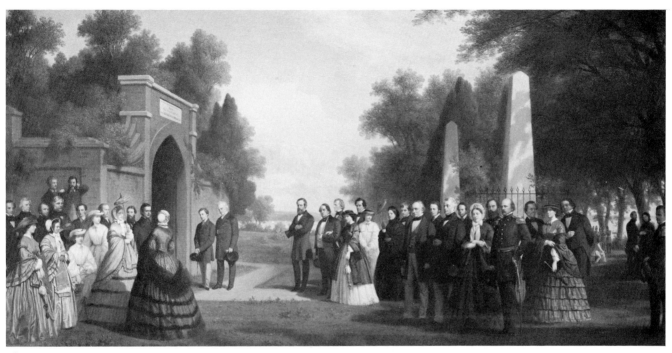

6

throughout the tumultuous years of the first half of the nineteenth century, from the War of 1812 through the Civil War, to assert the virtues of liberty and union. Thus was a celestial Washington a further manifestation of the ever-increasing greatness of America and a timely representation of the apotheosis of federalism.

Puritanism did not confine the nationalist imagination to portraiture, however. Founded as it was on prophecy, the Puritan myth of a New World of the elect directed Americans continually to seek different forms of expression to describe the growing beneficence of Providence. Each generation of Americans would, by building on the past, become successively more holy; an ever-more illustrious America would demand interpretation. America's progress from New England colonies to United States, the capacity of Washington to surpass Moses, and the continuing revelation of God's reward through the vastness of an ever-expanding landscape are all examples of the signs nationalists read as progress of America's religious spirit. New World observers bent on establishing a cosmic order within America, found in nature the process of renewal which they felt in themselves and in the national covenant. Consequently, American landscape became infused with the iconic significance of the country's heroes and history—with "Yankee Genesis," one contemporary historian has called it.[55] Contemplation of nature could reveal God's hand in America just as contemplation of Washington in majesty revealed special dealing of the divine.

The New World landscape was regarded, in the nineteenth century, as "the creation of the one God—his sensuous image and revelation, through the investigation of which by science of its representation by art men's hearts are lifted toward Him."[56] Gazing upon it, therefore,

would always elicit within the observer the emotion of the sublime. One of the most sublime views America had to offer was the site of the sacred remains of Washington in the tomb at Mount Vernon on the banks of the Potomac. As early as 1800 it became the subject of a memorial print.[57] Landscape painters were drawn to the subject in their quest for the divine in nature and many, like Boston painter William Matthew Prior (1806–73), sketched not at the site itself but from the widely-known engraved view after London illustrator William Bartlett (1809–54). Such separation from reality allowed Prior to further romanticize the scene (5). Prior intensifies his theme of death through symbolic use of repeated horizontals, by the dark sky of dusk, and by a mysterious black figure on horseback approaching the tomb from a lower central point in the composition. In Prior's *Mount Vernon and the Tomb of Washington*, all nature is dressed in mourning and weeps at the hero's tomb.

A second treatment of the subject also makes its point through use of visual metaphor. Thomas Rossiter's (1818–71) *Visit of the Prince of Wales, President Buchanan, and Dignitaries to the Tomb of Washington at Mount Vernon, October 1, 1860* (6) reports in straightforward manner the actual visit of his Royal Highness Albert Edward to the sacred shrine. The symbolic significance of the event was of special importance for nationalists. That the "heir-apparent to the British throne should visit the grave of a victorious British rebel,"[58] was itself an incident sublime, a representation of the moral impact of America on the corrupt Old World. Rossiter witnessed the sacred ceremony and sketched the participants from life and from photographs. Yet, the artist does more than recount details and facts. He imbues the scene with the spirit of Washington in two distinct ways. First, he invests the scene with the hero's spirit *symbolically,* by inviting the onlooker to stand at close range and contemplate the tomb along with the awe-struck dignitaries. Secondly, Rossiter captures Washington's spirit quite *literally,* through the subtle illusion of his unmistakable profile in the clouds overhead. Thus did God in nature impress the adumbration of his agent upon the American landscape.

In the theme of the apotheosis of Washington in American art is concentrated a survey of the nation's efforts to find ample means to express a sacred past and prophetic future, a Puritan belief that inspired an evangelical American nationalism to flourish. Godlike Washington was a fitting emblem for the nation's aspirations, as much spiritual as they were cultural, political, and economical. The nobility of the American character was embodied in his stature and countenance, and artists alone were capable of defining the significance of his image completely:

> It is worth remarking that the general statement of respect and affection for this eminent man was so exalted, that few of the orators did, or could, come up to the demand. . . . Washington's character was rather to be contemplated than talked of. . . .[59]

A century of heroic portraits is testimony to that unutterable regard.

Patricia A. Anderson
1980

NOTES

1. Keating Lewis Simons, *An Oration Delivered in the Independent Circular Church, Before the Inhabitants of Charleston, South Carolina, on Friday the Fourth of July, 1806; in Commemoration of American Independence,* (Charleston, [1806]), 11, quoted in Robert P. Hay, "Providence and the American Past," *Indiana Magazine of History* LXV (June, 1969), 88.

2. William Burlie Brown, *The People's Choice: The Presidential Image in the Campaign Biography* (Baton Rouge, Louisiana, 1960), 145, quoted in Sacvan Bercovitch, *The Puritan Origins of the American Self* (New Haven and London, 1975), 148.

3. Gaylord Clark, "Lafayette and Washington, An Address Pronounced Before the Washington Benevolent Society. . . ," *The Literary Remains,* ed. Lewis Gaylord Clark (New York, 1844), 396.

4. A thorough discussion of this metaphor in Puritan literature is Bercovitch, *The Puritan Origins of the American Self.* Also see Robert P. Hay, "George Washington: American Moses," *American Quarterly* 21 (Winter, 1969), 780–92, and "Providence and the American Past."

5. *Maryland Journal and Baltimore Advertiser,* July 8, 1777, quoted in Hay, "George Washington: American Moses," 781.

6. Thomas Shepard (1605–49), *Autobiography,* quoted in Bercovitch, 118.

7. Increase Mather, Preface to Samuel Torrey (1632–1707), *Exhortation,* quoted *Ibid.,* 113–14.

8. Bercovitch traces the persistence of Puritan dogma in American literature from Cotton Mather through Walt Whitman.

9. *Virginia Gazette and Richmond and Manchester Advertiser,* July 7, 1794, quoted in Hay, "Providence and the American Past," 85.

10. Asher B. Durand engraved Raphael's *The Vision of Ezekiel* for American bank notes in 1812. Grolier Club, *Catalogue of the Engraved Work of Asher B. Durand* (New York, 1895), no. 209, 91, lists the subject of the vignette as "Jove." I am grateful to Elizabeth Harris, Curator of Prints, the National Museum of History and Technology, Smithsonian Institution for bringing this engraving to my attention.

11. See Hay, "George Washington: American Moses," and Bercovitch, 148–51 passim; cf. Thomas Minns, "Some Sobriquets Applied to Washington," *Publications of the Colonial Society of Massachusetts* VIII (Boston, 1906), 275–87; also cf. Howard Mumford Jones, "Roman Virtue," in *O Strange New World American Culture: The Formative Years* (New York, 1965), 227–72.

12. Thomas Robbins, preface to Mather *Magnalia,* I, 6, quoted in Bercovitch, 87.

13. Harriet Beecher Stowe, quoted *Ibid.,* 86–87.

14. *Ibid.,* 87.

15. Bercovitch defines the principle of Inversion, 114.

16. Samuel Sewall, in Samuel A. Green, "Verses by Chief Justice Sewall," *Massachusetts Historical Society Proceedings,* 2d series (1885–86), vol. 2, 42, quoted *Ibid.,* 121.

17. Edward Johnson, *Wonder Working Providence of Sions Saviour in New England,* Chapter XXVI (Delmar, New York: Scholars' Facsimiles and Reprints, 1974), 152.

18. Benjamin Thompson, "New Englands grand Eclips. . . ," quoted in Bercovitch, 121.

19. David Humphreys, "Address to the Armies of America," quoted in William Alfred Bryan, *George Washington in American Literature, 1775–1865* (New York, 1952), 128.

20. Samuel Sewall, "Dedicatory Letter," *Phaenomena Quaedam Apocalyptica,* 27, quoted in Bercovitch, 99.

21. Hay, "George Washington: American Moses," 782, n. 14.

22. *Ibid.,* n. 15; Deuteronomy 34:1-8.

23. Frederick W. Hotchkiss, *An Oration Delivered at Saybrook on Saturday, February 22d, 1800. . .* (New London, Connecticut, 1800), 11, quoted *Ibid.,* 785.

24. Isaac Braman, *An Eulogy on the Late General George Washington. . . Delivered at Rowley, Second Parish. . .* (Haverhill, Massachusetts [1800]), 5, quoted *Ibid.,* 783.

25. Hotchkiss, *Oration,* quoted *Ibid.,* 785.

26. Hollis Read, *The Hand of God In History,* quoted in David C. Huntington, *Art and the Excited Spirit* (Ann Arbor, Michigan, 1972), 10.

27. For a discussion of the religious impulse in American art see Joshua Taylor's essay in Jane Dillenberger and Joshua C. Taylor, *The Hand and the Spirit: Religious Art in America, 1700–1900* (Berkeley, California, 1972), 10–24.

28. Neil Harris, *The Artist in American Society* (New York, 1966), 51.

29. Taylor, *The Hand and the Spirit,* 12.

30. Sir Joshua Reynolds, *Discourses on Art,* ed. Robert R. Wark (New Haven and London, 1975), III, 45.

31. Benjamin West to Charles Willson Peale, in William Dunlap, *History of the Arts of Design of the United States,* 3 vols., ed. Frank W. Bayley and Charles E. Goodspeed (Boston, 1918), I, 90–91.

32. *Ibid.*

33. Benjamin West, Discourse before the Royal Academy, 1797, quoted in Grose Evans, *Benjamin West and the Taste of His Times* (Carbondale, Illinois, 1959), 32.

34. Marquis de Chastellux, *Travels in America*, 2 vols. (London, 1787), I, 137–38.

35. George Mercer, quoted in John Hill Morgan and Mantle Fielding, *The Life Portraits of Washington and Their Replicas* (Philadelphia, 1931), xviii.

36. Irma B. Jaffe, *John Trumbull: Patriot-Artist of the American Revolution* (Boston, 1975), 315.

37. John Trumbull, "Appendix: Catalogue of Paintings by Colonel Trumbull . . . Now Exhibiting in the Gallery of Yale College. . . ," *Autobiography, Reminiscences, and Letters, from 1756–1841* (New York, New Haven, and London, 1841), 435–36.

38. George Richardson, "Subscribers," *Iconology; Or a Collection of Emblematical Figures* (London, 1779), volume First, n.p.

39. *Ibid.*, title page.

40. *Ibid.*, preface, n.p.

41. Ann Hope, "Césare Ripa's Iconology and the Neoclassical Movement," Supplement to *Apollo Magazine* (October, 1967), 1–4.

42. Jones, *O Strange New World American Culture*, 254.

43. For contemporaneous accounts see: Philip Freneau, "Lines, Intended for Mr. Peale's Exhibition, May 10, 1784," in Fred Lewis Pattee, ed., *The Poems of Philip Freneau*, 3 vols., II, 247–49; Francis Hopkinson, Esqr., "An Account of the Grand Federal Procession . . . the 4th of July 1778," *The Miscellaneous Essays and Occasional Writings*, 4 vols. (Philadelphia, 1792), II, 349. Also see Society of Iconophiles, *Washington's Reception by the Ladies of Trenton . . . as he passed under the Triumphal Arch Raised on the Bridge over the Assunpink, April 21st, 1789* (New York, 1903), 3–14. For one of the few sources of detailed descriptions of ephemeral displays in the corpus of one artist's work, see Charles Coleman Sellers, "Charles Willson Peale with Patron and Populace," *Transactions of the American Philosophical Society* 59, Part 3 (1969): S35, S36, S38, S40, S43, S57, S69, S82, S90, S104, S106.

44. H. P. L'Orange, *Apotheosis in Ancient Portraiture* (Oslo, 1914), figs. 21, 61.

45. Richard Brilliant, "Gesture and Rank in Roman Art: The Use of Gestures to Denote Status in Roman Sculpture and Coinage," *Memoirs of the Connecticut Academy of Arts and Sciences* XIV (February, 1963), 55–58, fig. 2.105, 97.

46. George Rogers, *Explanation of the Painting by James Burns of Washington Crowned by Equality, Fraternity, and Liberty* (New York, 1850), 2–16.

47. H. P. L'Orange, *Studies on the Iconography of Cosmic Kingship in the Ancient World* (Oslo, 1953), 27–34.

48. *The Monthly Anthology* 1 (1804), 109, quoted in Jones, *O Strange New World American Culture*, 232.

49. *Analectic Magazine* VI (November, 1815), 371, quoted in Lillian B. Miller, "Paintings, Sculpture, and the National Character, 1815–1860," *Journal of American History* 53 (March, 1967), 699.

50. Quatremere de Quincy, *Le Jupiter Olympian* (Paris, 1815), pl. XVI.

51. Nathaniel Hawthorne, quoted in Daniel J. Boorstin, *The Americans: The National Experience* (London, 1966), 355.

52. Reynolds, *Discourses*, XV, 276.

53. Pierluigi di Vecchi, *The Complete Paintings of Raphael* (New York, 1966), 117.

54. Hay, "George Washington American Moses," 289–91; William A. Bryan, "George Washington: Symbolic Guardian of the Republic, 1850–1861," *William and Mary Quarterly* VII (January, 1950), 53–63.

55. R. W. B. Lewis, quoted in Barbara Novak, "American Landscape: The Nationalist Garden and the Holy Book," *Art in America* 60 (February, 1962), 49.

56. James Jackson Jarves, quoted *Ibid.*

57. Davida Deutsch, "Washington Memorial Prints," *Antiques* 111 (February, 1977), 330.

58. Mark Thistlethwaite, *The Image of George Washington: Studies in Mid-Nineteenth Century American History Painting*, Ph.D. dissertation, the University of Pennsylvania, 1977 (Ann Arbor, Michigan: University Microfilms, 1977).

59. William Sullivan, *Familiar Letters on Public Characters and Public Events, From the Peace of 1783 to the Peace of 1815* (Boston, 1834), 140.

Catalogue of the Exhibition

PAINTINGS AND DRAWINGS

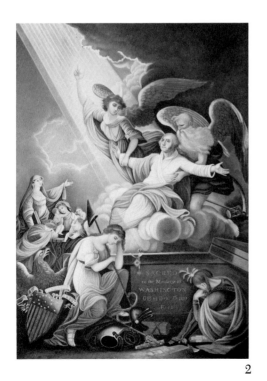

2

1. **Unidentified Artist.** American (Connecticut), 19th century

 Washington and Miss Liberty. c. 1800–1810
 Oil on windowshade. Framed: 74 x 44 in. (198 x 11.8 cm.)
 Inscribed upon pedestal at left: *FIRST IN WAR,/ FIRST in PEACE,/ and/ FIRST in the HEARTS/ OF HIS/ COUNTRYMEN.*

 The New York Historical Association, Cooperstown, New York

 LITERATURE
 E. L. Horwitz, *The Bird, the Banner, and Uncle Sam* (New York, 1976), 69

2. **Anonymous.** Chinese, for the American market, Early 19th century

 Apotheosis of George Washington
 Reverse painting on glass. 28½ x 20½ in., sight (72.4 x 52.1 cm.)

 Museum of the American China Trade. Anonymous gift, 1978

 LITERATURE
 C. L. Crossman, "China Trade Paintings on Glass," *Antiques* 95 (March, 1969), 375; Jacobs, 134

3. **Rembrandt Lockwood.** American, active 1840–55

 The Last Judgment
 Pencil, chalk, charcoal, and wash. 37 x 24 in. (94 x 61 cm.)
 Inscribed, in pencil, upper left: *St. Matthew/Chap XXV/ Verse—*; upper right: *Revelation/Chap I/Verse 7*

 Collection of the Newark Museum. Gift of Vose Galleries and William Gannon

 PROVENANCE
 Vose Galleries; to Newark Museum, 1965

 LITERATURE
 Key to and Description of . . . "The Last Judgment," a Scriptural Painting by Rembrandt Lockwood (Newark, New Jersey, 1854); W. H. Gerdts, "Rembrandt Lockwood, an Artist of Newark," *Proceedings of the New Jersey Historical Society* 76 (October, 1958), 265–78; Jacobs, 135–37, fig. 21; Thistlethwaite, fig. 163

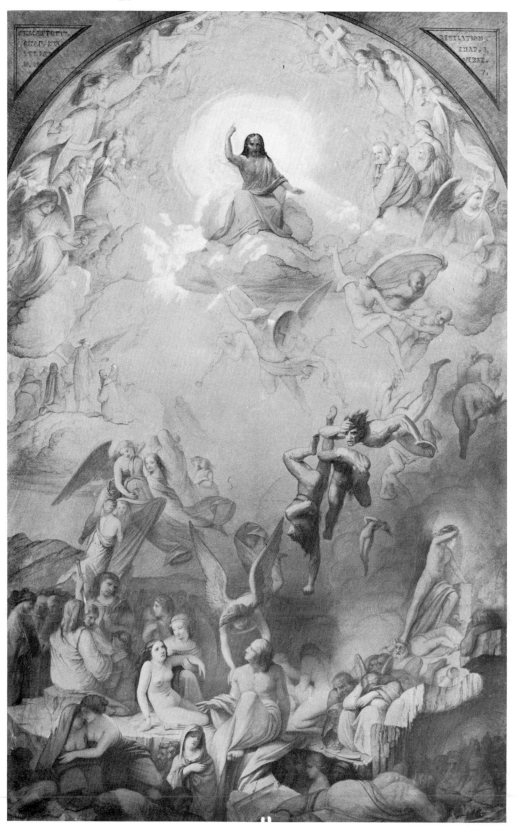

This drawing is a preparatory sketch for a monumental canvas, now lost, by Newark artist Rembrandt Lockwood. Entitled *The Last Judgment*, the scene is a patriotic American's version of the texts of Matthew XXV:31, 34, 41 and Revelations I:7. Among representatives of Mankind issuing from the grave is Washington, "as the type of Liberty,"[1] who occupies a central position in the lower register of the composition. The hero's symbolic role is heightened by an accompanying figure of a weak slave girl, a juxtaposition described thus in a contemporaneous key to the picture:

> In the lassitude of her form is seen the physical and mental depression incident to a state of bondage; while the figure of liberty is full of life and vigor. An angel supports the slave and watches the returning life as it beams through her dark, lustrous eyes, confidingly upward to the Saviour. The Angels receiving these figures are intended to teach that God's tender care is alike over all—the most humble as well as the most exalted.[2]

In addition to portraying Christian virtues and divine majesty, Lockwood has apotheosized culture itself, placing in the realm of heaven figures of the sciences, arts, and letters: Galileo, Pascal, Erasmus, Plato, Dante, Michelangelo, Raphael, and Titian.

1. *Key to and Description of . . . "The Last Judgment;" a Scriptural Painting by Rembrandt Lockwood* (Newark, New Jersey, 1854), 1.
2. *Ibid.*

4. **Rembrandt Peale.** American, 1778–1860

George Washington
Oil on canvas. 35¾ x 29 in. (90.8 x 73.7 cm.)
Inscribed, lower left, upon simulated stone surround:
Rembrandt Peale

Mead Art Museum, Amherst College, Amherst, Massachusetts. Bequest of Herbert L. Pratt '95.

EXHIBITIONS
Brooklyn, New York, Brooklyn Institute of Arts and Sciences, *Early American Paintings*, 1917, no. 72; Amherst, Massachusetts, Mead Art Museum, *Benjamin West: His Times and his Influences*, 1950

LITERATURE
[Rembrandt Peale], *Portrait of Washington* (Philadelphia, n.d.), 20 pp.; J. D. Godman, *Ode Suggested by Rembrandt Peale's National Portrait of Washington* (Philadelphia, 1824), n.p.; Dunlap I, 349; C. H. Hart, *Works of American Artists in the Collection of Herbert L. Pratt* (Amherst, 1917), 56–57; Morgan and Fielding, 378, no. 10; C. H. Morgan and M. C. Toole, "Benjamin West: His Times and his Influence," *Art in America* XXXVIII (December, 1950), 271–72, illus. op. 271; Philadelphia Museum of Art, *Philadelphia: Three Centuries of American Art* (Philadelphia, 1976), 259

The ancient world conceived the *clipeus*, or circular shield surrounded by a border, as an emblem of "the revolving All, the cosmos."[1] The *clipeus* appeared in sepulchral art of Rome to imply "the immortal circle of God,"[2] within which Romans inscribed images of the deceased, particularly emperors and heroes, to elevate a fallen individual to the realm of heaven. Rembrandt Peale was probably aware of such sepulchral iconography when he

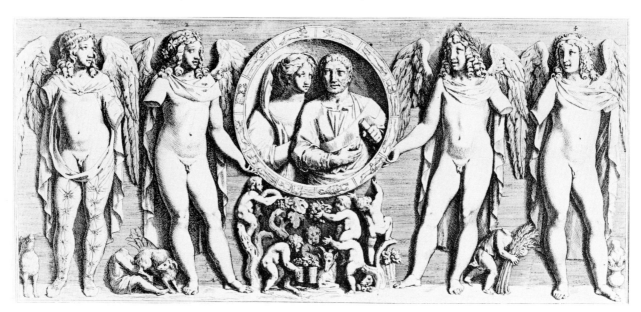

Figure 9. *Quat vor Anni Tempora* from Pietro Bartoli, *Admiranda Romanarum Antiquitatum* (Rome, 1693), Pl. 78. Hillyer Art Library, Smith College.

4

painted a demigod Washington within a *trompe l'oeil* stone surround, suggestive of the carving on Roman sacophagi (fig. 9). Peale produced some seventy copies of this "Porthole" portrait, the head of which was modeled on the artist's life portrait of 1795. A version which he took on tour in 1823–25 was that purchased by the United States Congress in 1832, a heroically-scaled canvas, the spandrel of which contains a mask of the Phidian *Zeus* in the keystone and the inscription *Patriae Pater*. At least one viewer perceived an image of apotheosis in the Porthole portrait and wrote in exultant verse of how the Peale painting fulfilled art's greatest gift of rebirth:

Triumphant Art! By whom the mighty dead,
Long snatched from sight and solemnly entombed,
Again spring up! with living lustre spread
O'er every feature by the touch relumed!—
How mildly dignified! How nobly grave!—
A purer joy can freemen wish to share
Than when is burst the dark sepulchral cave
And *thus*, in life's expressiveness, appear
The great, who Godlike lived and glorious died;
Who served and saved their country—who have been
Her shield and strength, through war's appalling scene;
In peace, her honour, guardian, ornament or pride.

. . .

"His country's father!" Glory! Say, can'st thou
Select from thy resplendent diadem
To spread one beam o'er such an honoured brow,
Another richer or more lustrous gem?
"The friend of man—of virtue—Freedom's dauntless son,
"Hero of ages"—Oh how vain it were
To speak the titles which his worth has won,
Or his surpassing excellence declare
Could we not sum them all and call him WASHINGTON.[3]

1. H. P. L'Orange, *Studies on the Iconography of Cosmic Kingship in the Ancient World* (Oslo, 1953), 90.

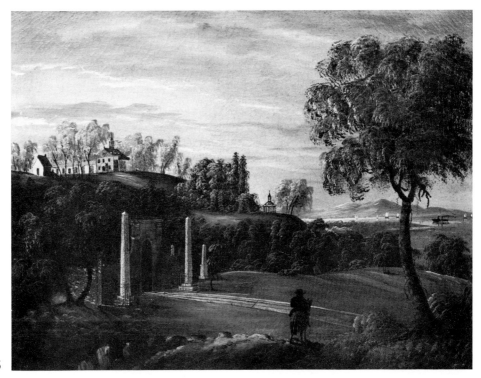

5

2. *Ibid.*

3. J. D. Godman, *Ode Suggested by Rembrandt Peale's National Portrait of Washington* (Philadelphia, 1824), stanzas I and XI, n.p.

5. **William Matthew Prior.** American, 1806–73

> *Mount Vernon and the Tomb of Washington.* c. 1860
> Oil on canvas. 18¾ x 28¾ in. (47.7 x 73 cm.)
> Stenciled verso: *Painting Garret, No. 36 Trenton St. East Boston, W.M. Prior*

> Smith College Museum of Art, Northampton, Massachusetts. Purchased, 1950

> PROVENANCE
> Unknown antique shop, Plymouth, Massachusetts; to Smith College Museum of Art, 1950
> EXHIBITIONS
> Amherst, Massachusetts, Jones Library, *American Art I,* 1958; *19th and 20th Century Paintings from the Collection of the Smith College Museum of Art* (an exhibition circulated by the American Federation of Arts), 1972, no. 46; Trenton, New Jersey, New Jersey State Museum, *This Land is Your Land,* 1976
> LITERATURE
> G. A. Lyman, "William M. Prior, The 'Painting Garret' Artist," *Antiques* XXVI (November, 1934), 108; "Recorders, Deceivers, Dreamers," *Kennedy Quarterly* V (January, 1965), 106–7

6. **Thomas Rossiter.** American, 1818–71

> *Visit of the Prince of Wales, President Buchanan and Dignitaries*

to the Tomb of Washington, October 1, 1860. 1861
Oil on canvas. 27¼ x 54⅜ in. (69.3 x 138.1 cm.)
Signed and dated in oil, lower right: *T. P. Rossiter/1861*

National Collection of Fine Arts, Smithsonian Institution, Washington, D. C. Harriet Lane Johnston Collection

EXHIBITIONS
Washington, D.C., National Museum of History and Technology, Smithsonian Institution, *Silver Jubilee of Queen Elizabeth II,* 1977

LITERATURE
R. Rathbun, *The National Gallery of Art* (Washington, D.C., 1909 and 1916), 98; W. H. Holmes, *The National Gallery of Art, Catalogue of Collections* (Washington, D.C., 1922), 62 and (1926), 74; Thistlethwaite, 192–202, fig. 165

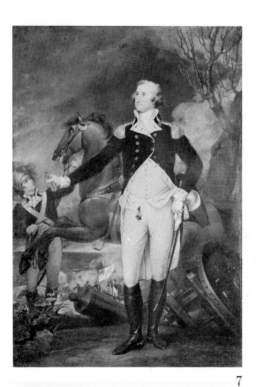

7

7. **John Trumbull.** American, 1756–1843

General George Washington Before the Battle of Trenton. After 1792
Oil on canvas. 26½ x 18½ in. (67.3 x 47 cm.)

The Metropolitan Museum of Art, New York City. Bequest of Grace Wilkes, 1922

PROVENANCE
Charles Wilkes, New York; the Wilkes Family; Grace Wilkes; to Metropolitan Museum of Art, 1922

EXHIBITION
Chicago, Illinois, Art Institute of Chicago, *From Colony to Nation,* 1949, no. 123

LITERATURE
J. Trumbull, *Autobiography, Reminiscences, and Letters, from 1756–1841* (New York, London, and New Haven, 1841), 435, no. 41; H. T. Tuckerman, *The Character and Portraits of Washington* (New York, 1859), 50–51; A. T. E. Gardner and S. Feld, *American Paintings, A Catalogue of the Collection of the Metropolitan Museum of Art* (New York, 1965), I, 103–4, illus. 104; Sizer, 83; Jaffe, 158–60, 315; J. K. Howat, "A Young Man Impatient to Distinguish Himself," *Metropolitan Museum Bulletin* 29 (March, 1971), 339, fig. 6; M. Brown, *American Art to 1900,* 191, fig. 271

This version of *General Washington Before the Battle of Trenton* is a replica by Trumbull after the large-scale original now in the Yale University Art Gallery. The portrait was commissioned by the citizens of Charleston, South Carolina in 1792 but ultimately rejected. A second, less emotional, more "matter-of-fact"[1] likeness was subsequently painted for the artist's commissioners, and it hangs in Charleston's City Hall. It was Trumbull's classicizing which caused trouble for him in the assignment. As he wrote in his *Autobiography:*

> This picture was intended to preserve the *military* character of the great original; but the citizens of Charleston being desirous of seeing him rather in his civil character, such as they had recently seen him in his visit to that city, another picture was, with the kind consent of the president, begun and finished. . . .

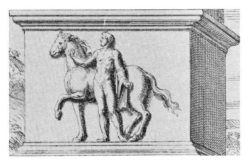

Figure 10. *Sepulcro antico passato il Ponte lucano avanti arrevare in Tivoli nell a Vignia del Sigr. Domenico Gentile* (detail), from Pietro Bartoli, *Gli Antichi Sepolcri overo Mausolei Romani et Etruschi* (Rome, 1697), Pl. 47. Hillyer Art Library, Smith College.

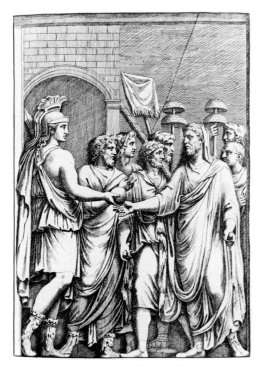

Figure 11. *Providentiae Augustii* from Pietro Bartoli, *Admiranda Romanarum Antiquitatum* (Rome, 1693), Pl. 6. Hillyer Art Library, Smith College.

In the countenance of the hero, *the likeness*, the mere map of the face, was not all that was attempted, but the features are animated, and exalted by the mighty thoughts revolving in the mind on that sublime occasion; the *high resolve*, stamping on the face and attitude its lofty purpose, to conquer or to perish.[2]

The idealized hero is shown before the backdrop of the pivotal Revolutionary War battle at Trenton, New Jersey. There Washington staged a surprise attack on the Hessians after cunningly building conspicuous campfires along the Assunpink Creek to make Cornwallis believe that the patriot garrison lay unsuspecting at post. Trumbull, who had been an aide to General Washington, described the details of the picture:

He is represented in full uniform, standing on an eminence, on the south side of the creek at Trenton, a small distance below the stone bridge and mill. He holds in his right hand his reconnoitering glass, with which he is supposed to have been examining the strength of the hostile army, pouring into and occupying Trenton, which he had just abandoned at their approach; and having ascertained their great superiority, as well in numbers as discipline, he is supposed to have been meditating how to avoid the apparently impending ruin . . . and he is supposed to have just formed the plan of the movement which he executed during the succeeding night. This led to the splendid success at Princeton, on the following morning; and in the estimation of the great Frederick of Prussia, placed his military character on a level with that of the greatest commanders of ancient or modern times.

Behind and near him an attendant holds his horse; further back are seen artillery, assisting in the defense of the bridge and mill, against the attack made by the enemy, a little before sunset; the bridge and mill are seen under the legs of the horse, and higher up in the perspective distance, are seen several glimpses of the creek in its windings; and the fires which so fatally divided the enemy during the night, are in many places already lighted and visible.[3]

To effect an image of omnipotence, Trumbull enlisted the service of many well known classical antecedents to Washington. Reference to that most revered of ancient statues, the *Apollo Belvedere* (fig. 1) is understandable, as General Washington had been likened, in poise and stature, to that classic statue in contemporaneous descriptions. A deliberate allusion to imperial apotheosis is also suggested by the frontal figure in the *ad locutio* pose, an image not unlike iconic forms of public sculpture and sepulchral monuments of ancient Rome. Popular volumes on Roman antiquities, illustrated by seventeenth-century Italian engraver Pietro Santi Bartoli, might easily have been Trumbull's source for depictions of divinely-inspired Roman emperors. Trumbull's mentor Benjamin West had drawn from Bartoli's *Admiranda Romanarum Antiquitatum* (Rome, 1693). With the elder expatriate in London, Trumbull, classically educated at Harvard College, must have turned to the same volume in his own assiduous study of antiquities. A Roman sepulchral monument (fig. 10) and a scene of Augustus in triumph (fig. 11) from Bartoli illustrate the classical manner of rendering omnipotent men and are but two of many examples of imperial apotheosis published by the seventeenth-century antiquarian.

1. Representative William Smith of South Carolina, who acted for the citizens of Charleston in the commission; quoted in Jaffe, 158.

2. Trumbull, *Autobiography, Reminiscences and Letters, from 1765–1841* (New

8 *PRINTS*

York, London, and New Haven, 1841), 435, 436.

3. *Ibid.*, 435.

4. See G. Evans, *Benjamin West and the Taste of His Times* (Carbondale, Illinois, 1959), pls. 1 and 2.

8. **Unidentified Artist**

 American Freedom Established by Valour and Perseverence
 from *The Essence of Agriculture*
 Engraving. Image: 7⅛ x 4⅝ in. (18.1 x 11.8 cm.)
 Inscribed: *His Excellency George Washington. Commander in/ Chief of the American Armies, Marshall of France & c.*

 The Historical Society of Pennsylvania, Philadelphia. Baker Collection

 LITERATURE
 Baker 160; Hart 88

9. **James Akin.** American, c. 1773–1846
 and
 William Harrison, Jr. American, active 1797–1819

 American Lamenting Her Loss at the Tomb of Washington. 1800
 Engraving. Sheet: 13¼ x 8½ in. (33.6 x 21.6 cm.)
 Inscribed: *Design'd, Engrav'd and Publish'd by Akin & Harrison Junr. Philada. Jany. 20th 1800./ America Lamenting her Loss at the Tomb of/ General Washington/ Intended as a Tribute of respect paid to departed Merit & Virtue, in/ the remembrance of that illustrious Hero and most Amiable man who Died Decr. 14: 1799.* On tomb tablet at center: *G. Washington./ Born 11th Feby. O.S. 1732./ Comr. Contl. Army 1775/ Prest. Fed: Convention 1787./ Prest. United States 1789/ Declined Election 1796./ Comr. Fedl. Army 1798.*

 Stanley Deforest Scott

 PROVENANCE
 Old Print Shop, New York; to Stanley Deforest Scott, 1970
 EXHIBITION
 New York, 1976
 LITERATURE
 Baker 400; Hart 147; Stauffer 22; Taylor, 30; Deutsch, 324, fig. 1

This memorial print from the short-lived partnership of Philadelphia engravers James Akin and William Harrison, Jr. records a dramatized mourning spectacle staged at the capital city's New Theatre only days after Washington's death.[1] The stage set, designed by Cotton Milbourne, John Joseph Holland, and John James Barralet, was described in J. Russel's *Gazette*, January 9, 1800:

> The house which, was "full to overflowing," displayed a scene calculated to impress the mind with the utmost solemnity and sorrow. The pillars supporting the boxes were incircled with black crape, the chandeliers were decorated with the insignia of woe, and the audience, particularly the Female part, appeared covered with the badges of mourning. About 7 o'clock the band struck up *"Washington's March,"* after which, a solemn dirge was played, when the curtain slowly rising, discovered a Tomb in the centre of the stage in the Grecian Style of Architecture. . . . In the center was a portrait of the General, incircled

9

America lamenting her Life at the Tomb of
GENERAL WASHINGTON.

by a wreath of oaken leaves; under the portrait a sword, shield and helmet and the colours of the United States. The top was in the form of a Pyramid, in the front of which appeared the American Eagle, weeping tears of blood for the loss of her General, and holding in her beak a scroll, on which was inscribed, *"a nation's tears."*[2]

The production also included an accompanying monody composed by Alexander Reinagle and Raynor Taylor, one of the airs of which was this lament:

> Slowly stroke the solemn bell;
> Nature, sound thy deepest knell—
> Pow'r of Music! touch the heart,
> Nature there will do her part.

> God of Melancholy, come,
> Pensive o'er the Hero's tomb;
> In saddest strains his loss deplore,
> With piercing cries rend ev'ry shore,
> For Washington's no more![3]

The profile bust of Washington in the first state is based on a portrait by Joseph Wright (1756–93). In this second state of the print, the portrait has been reworked to resemble a profile by James Sharples.

1. For contemporaneous accounts see *Gazette of the United States*, Philadelphia, December 21, 1799 and *True American & Commercial Advertiser*, Philadelphia, December 24, 1799, quoted in Deutsch, 324, fig. 1.
2. Quoted in V. B. Lawrence, *Music for Patriots, Politicians, and Presidents: Harmonies and Discords of the First Hundred Years* (New York, 1975), 157.
3. *Ibid.*

10

10. **Vistus Balch.** American, 1799–1884
after
Henry Inman. American, 1801–46

Memorial to Washington: Washington Crowned by Liberty
Line engraving. 9 x 5 in. (22.9 x 12.7 cm.)
Inscribed: *Inman del.—Balch sc.*; upon urn at left: *G.W.*

The Historical Society of Pennsylvania, Philadelphia. Baker Collection

LITERATURE
Hart 773; Fielding *Supplement* 104

11. **John James Barralet.** American, born Ireland, c. 1747–1815

Commemoration of Washington. After 1816; first state 1802
Stipple engraving. Sheet: 25¾ x 19⅞ in. (65.4 x 50.6 cm.)
Inscribed upon tomb: *I. J. Barralet/Fecit/Sacred/to the Memory of/Washington/OB 14 Dec AD 1799/AEt 68;* at bottom: *Drawn and Engraved—by J. J. Barralet/COMMEMORATION OF WASHINGTON*

Stanley Deforest Scott

EXHIBITION
New York, 1976

LITERATURE
Baker 406; Hart 675b; Stauffer 118; Dreppard, 86; Brown University, no. 16; Schorsch, 5, fig. 1; Taylor, 32, illus. 35; Deutsch, 329, fig. 12; Jacobs, 116, fig. 1

John James Barralet, an eccentric Irish immigrant artist of French descent, and French *emigré* print seller Simon Chaudron first advertised this print for subscription in the Philadelphia *Aurora, for the Country* on December 19, 1800, describing it:

> The Subject *General* WASHINGTON raised from the tomb, by the spiritual and temporal GENIUS—assisted by Immortality. At his feet AMERICA weeping over his Armour, holding the staff surmounted by the Cap of Liberty, emblematical of his mild administration, on the opposite side, an Indian, crouched in surly sorrow. In the third ground the mental virtues, Faith, Hope, and Charity.[1]

The large engraving was issued in January, 1802 and reissued throughout the early decades of the nineteenth century.[2] On April 2, 1803, Boston's Federal Street Theatre staged the design as:

> A Grand Transparent Painting. (Executed by Mr. *Graham* [probably George Graham, listed in Boston directories of 1798 and 1803])—Taken from Barralett's celebrated Picture. The figures large as life. *The Subject the IMMORTALITY OF WASHINGTON.* Representing *Washington*, ascending to the Regions of Immortality, borne by two elegant figures, of Time and an Angel. The Genius of Columbia, as an Indian, lamenting over the Tomb of *Washington* as Grand Master. Emblems, as Father of the Cincinnatti. . . .[3]

At least two replicas of Barralet's image were painted in oil upon canvas by anonymous admirers;[4] and impressions of the print made their way to England and the Orient, where they were copied on Liverpool transfer-printed creamware and as Chinese reverse paintings on glass for the American market (see 2 and 41).

Barralet modeled his portrait of Washington on Gilbert Stuart's Athenaeum head, but he perhaps drew his semi-recumbent, levitating figure from engravings after Raphael's *Vision of Ezekiel* (fig. 8). The salient features of the design may be based upon a memorial spectacle staged by one group of Philadelphia Masons in which Barralet's co-publisher Chaudron played a feature role. Scharf and Westcott in their late-nineteenth-century *History of Philadelphia, 1609–1884*, found this particular Masonic tribute worthy of lengthy description eighty-four years after its production, so one must presume that the event had considerable impact on Philadelphians of Barralet's day:

> Among the ceremonies on this occasion none were more impressive than those which were directed by the French lodge L'Amenité, no. 73. The brethren ordered that an oration should be delivered in open lodge, under the most solemn and impressive forms of the master's lodge. Brother S. Chaudron was chosen to deliver the address. The lodge-room was accordingly completely hung in black. In the centre, on a platform, to which the ascent was by *five* steps, a bier was raised, with the Mason's insignia and military decorations proper to the character of the deceased, surrounding which were several urns suitably decorated. Over and surrounding the bier, which stood ten feet above the lodge, black drapery was displayed from the ceiling, festooned, and knotted, and interspersed with suitable emblems. The catafalque was surrounded by more than three hundred lights.[5]

Chaudron's accompanying elegy employed the language of apotheosis and included exultations upon much of Barralet's emblemata, especially the mourning of the American Indian.[6] Thus, Chaudron and his elaborate mock funeral may have furnished Barralet with material for his design.

1. Quoted in Deutsch, 329, fig. 12.

2. Stauffer identifies four states of the engraving, the last issued after 1816.

3. I am grateful to Davida Deutsch for bringing this citation to my attention.

4. Though the paintings remain unlocated, Nancy Druckman of the Department of American Furniture and Decorative Arts has supplied me with a reproduction of one such work and a description of a second. Even in a reproduction, a stylization of the composition is quite apparent which suggests that the painting was a copy after rather than a prototype for the Barralet print. The canvas size of both paintings— 24½ x 19 inches—corroborates this assumption. See Sotheby Sale #148 (December 1, 1939), Lot #57, illus. 13 and Sotheby Sale #1157 (April 29, 1950), Lot #100. Each description attributes the painting to Barralet. Also see National Collection of Fine Arts, Smithsonian Institution, *Bicentennial Inventory of American Paintings Before 1914, Index* (Washington, D.C., 1976), 657, number 015. Pamela Jenkins, Assistant to the Coordinator of the Inventory, kindly provided me with details on this citation.

5. J. T. Scharf and T. Westcott, *History of Philadelphia, 1609–1884*, 3 vols. (Philadelphia, 1884), I, 504.

6. S. Chaudron, *Funeral Oration on Brother George Washington, Delivered January 1st, 1800, Before the French Lodge L'Amenité . . . Translated from the French by Samuel F. Bradford* (Philadelphia, 1800).

12. **Jacopo Bernardi.** Italian, born c. 1808
after
Horatio Greenough. American, 1805–52

> *George Washington.* c. 1840
> Engraving. Sheet: 16¼ x 11½ in. (42.5 x 29.2 cm.)
> Inscribed: *Horatio Greenough, Sculptor—Jacopo Bernardi, Engraver*

Department of Art, Brown University. Gift of Nathalia Wright

EXHIBITION
Providence, 1976, no. 25

LITERATURE
Whittemore, pl. VIII; W. Craven, "Horatio Greenough's Statue of Washington and Phidias' Olympian Zeus," *The Art Quarterly* XXXVI (Winter, 1963), 429–40; N. Wright, *Horatio Greenough, The First American Sculptor* (Philadelphia, 1963); S. E. Crane, *White Silence* (Miami, 1972); C. Vermeule, "America's Neoclassic Sculptors: Fallen Angels Resurrected," *Antiques* 102 (November, 1972), 869–70, fig. 6; W. Gerdts, *American Neoclassic Sculpture* (New York, 1973), 98–99; J. S. Crawford, "The Classical Tradition in American Sculpture: Structure and Surface," *American Art Journal* XI (July, 1979), 40–41, fig. 4

On February 18, 1832, the United States House of Representatives resolved:

> That the President of the United States be authorized to employ Horatio Greenough, of Massachusetts, to execute, in marble, a full-length pedestrian statue of WASHINGTON, to be placed in the centre of the rotundo of the Capitol; the head to be a copy of Houdon's WASHINGTON, and the accessories to be left to the judgment of the artist.[1]

Greenough judged the body of Phidias' Olympian *Zeus* appropriate to the Houdon likeness of *Pater Patriae.* Though the ancient Greek monument was destroyed in the fifth century A.D., Greenough's model was an important nineteenth-century reconstruction of the god enthroned published by French antiquarian Quatremere de Quincy in *Le Jupiter Olympian* (Paris, 1815; fig.

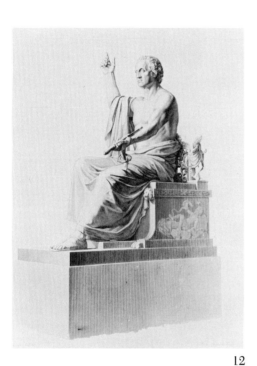

12

7). The same illustration was also a favorite figure of Greenough's acquaintance, French Neoclassicist Jean-Auguste-Dominique Ingres (1781–1867), from whom the Boston sculptor may have derived the idea of enlisting the ancient figure in the service of great men.[2]

Greenough's primary intention was not to deify Washington so much as it was to link American heroic sculpture with the artistic impulse of antiquity and thereby to elevate not only his subject, but the artist's own artistic enterprise. Nineteenth-century critic Alexander Everett understood his friend's inspiration, and likened Greenough to a poet of antiquity when he wrote of the *Washington* in 1853:

> The hint seems to have been taken from the Olympian Jupiter of Phidias, who said himself that he had caught the inspiration under which he conceived the plan of that great glory of ancient sculpture, from a passage in the Iliad. In this way the noble work of Greenough connects itself by the legitimate filiation of kindred genius, transmitting its magnetic impulses through the long lines of intervening centuries with the poetry of Homer.[2]

That Greenough altered the attitude of his subject, however, depicting Washington with sword reversed in a gesture of submission rather than of omnipotence, was essential in portraying an American democrat; and this more exalted theme, Everett rationalized, testified that the *Washington* surpassed in greatness its antecedent:

> . . . The vast dimensions of the Jupiter of Phidias may have made it to the eye a more imposing and majestic monument; but if the voluntary submission of transcendent power to the moral law of duty be, as it certainly is, a more sublime spectacle than any positive exercise of the same power over inferior natures, then the subject of the American sculptor is more truly divine than that of his illustrious prototype in Greece.[3]

Nevertheless, most Americans were not moved by the sublimity of what they perceived as a scantily-clad, overly-idealized Washington. The public ridiculed Greenough's effort as elitist and attacked the portrayal of the hero in semi-nudity as an act of irreverence against the great man. Rather than gracing the rotunda, the statue was ultimately relegated to an inconspicuous place on the Capitol grounds, where it was subject to overt displays of denigration. In 1847, one passerby noted:

> The last time I saw Greenough's colossal *Washington*, in the garden of the Capitol, some irreverent heathen had taken the pains to climb up and insert a large "plantation" cigar between the lips of the pater patriae. . . . I could not help thinking, at the time, that if *Washington* had looked less like the Olympic Jove, and more like himself, not even the vagabond who perpetrated the trick of the cigar would have dared or dreamed of such a desecration.[4]

1. House of Representatives, 27th Congress, *Doc. No. 45* (August 4, 1841), 1.

2. See Ingres' *Apotheosis of Homer*, Louvre, Paris; Craven, 437.

3. Alexander Everett quoted in H. T. Tuckerman, *A Memorial of Horatio Greenough* (New York, 1853), 224.

4. *Ibid.*

5. S. W. Wallis, quoted in Craven, 1.

13. **Thomas Clarke.** American, active 1797–1800

Sacred to the Memory of the Illustrious G. Washington. 1801
Stipple engraving. Sheet: 9 x 8½ in. (22.9 x 21.6 cm.)
Inscribed at bottom, in circular floriated double border:
T. Clarke Sculpt 1801 Boston; upon tablet at bottom: *Sacred to
the Memory of the Illustrious/G. Washington;* upon monu-
ment at right: *G. Washington./There is/Rest in/Heaven.*

Stanley Deforest Scott

PROVENANCE
Old Print Gallery, Georgetown, Washington, D.C.; to Stanley
Deforest Scott, 1973
EXHIBITION
New York, 1976
LITERATURE
Hart 279; Stauffer, 408

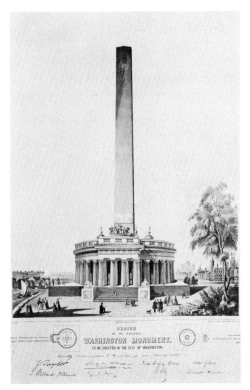

14

14. **Charles G. Crehen.** American, 1829–?
after
Robert Mills. American, 1781–1855

Design of the National Washington Monument
Lithograph. Sheet: 28¼ x 20 in. (71.7 x 50.8 cm.)
Inscribed: *C. G. CREHEN—ROBERT MILLS ARCH.—LITH.
OF WM. ENDICOTT & CO. N.Y./ DESIGN OF THE
NATIONAL WASHINGTON MONUMENT,/ TO BE
ERECTED IN THE CITY OF WASHINGTON./ Earnestly
recommended to the favour of our Countrymen–/ Z. Taylor—
James K. Polk—John Quincy Adams—Albert Gallatin/ Millard
Fillmore—G. M. Dallas—H. Clay—Danl Webster;* at left: *Base
of Pantheon 250 feet diameter/ height 100 feet, height of Obelisk
500 feet;* at right: *_____ has contributed/ $ _____ to the
erection of the Monument/ _____ Agent.*

The New York Historical Society, New York City

LITERATURE
H. M. P. Gallagher, *Robert Mills: Architect of the Washington
Monument* (New York, 1935); J. W. Reps, *Monumental
Washington, The Planning and Development of the Capital
Center* (Princeton, New Jersey, 1967), 44–45, fig. 23; National
Capital Planning Commission, *Worthy of the Nation: The His-
tory of the Planning for the National Capital,* R. W. Spiegel, ed.
(Washington, D.C., 1977), 51–52, illus. 52

In 1836, America's first native-trained architect, Robert Mills, won
the national competition for a Washington Monument in the capi-
tal city with his design for a 555-foot obelisk. This lithograph, sold
for subscription to the building project, preserves the original
plan, which called for a pantheon 250 feet in diameter with a Doric
colonnade. Mills' allusion to an ancient temple form was deliber-
ate use of symbolism appropriate to an apotheosized leader.

15. **Edward Dechaux.** American, 19th century

The Spirit of the Union. 1860
Lithograph. Sheet: 12¾ x 8¾ in. (32.2 x 22.3 cm.)
Inscribed: *Entered according to Act of Congress in the year*

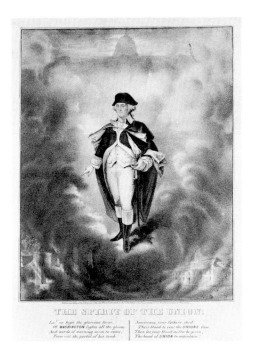

15

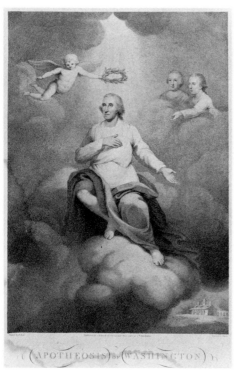

17

1860, by E. Dechaux, in the Clerk's Office of the United States, for the Southern District of New York/ THE SPIRIT OF THE UNION./ Lo! on high the glorious form,/ of WASHINGTON lights all the gloom:/ and words of warning seem to come,/ From out the portal of his tomb./ Americans your fathers shed:/ Their blood to rear the UNIONS fame./ Then let your blood as free be given,/ the bond of UNION to maintain

The American Antiquarian Society, Worcester, Massachusetts

LITERATURE
Thistlethwaite, 199, fig. 169

16. **Asher Brown Durand.** American, 1796–1886
after
Robert Walter Weir. American, 1803–89

The Arts Serving Virtue
Engraving. 7½ x 4⅞ in. (19.1 x 12.4)
Inscribed: *The Arts Serving Virtue*

The Historical Society of Pennsylvania, Philadelphia. Baker Collection

LITERATURE
Stauffer 663

17. **David Edwin.** American, 1776–1841
after
Rembrandt Peale. American, 1778–1860

Apotheosis of Washington. 1800
Stipple engraving. Sheet: 24 x 15½ in. (60.7 x 46.3 cm.)
Inscribed: *Painted by R. Peale—Published by S. Kennedy No. 129, Chestnut Street, corner of 4th. . Philadelphia—Engrav'd by Edwin./APOTHEOSIS OF WASHINGTON*

National Portrait Gallery, Smithsonian Institution, Washington, D.C.

PROVENANCE
Old Print Shop, New York; to National Portrait Gallery, 1977.
LITERATURE
Baker 402; Hart 702; Stauffer 904; Dreppard, 93; Sellers, "Charles Willson Peale with Patron and Populace," 33, 882; Deutsch, 328, fig. 11; Jacobs, 131, fig. 17, n. 36; NPG, *Illustrated Checklist*, 129

Philadelphia's first Washington's Birthday celebration following the hero's death saw the windows of Charles Willson Peale's Philosophical Hall resplendent with illuminated transparent displays, among which was perhaps an *Apotheosis of Washington* which provided the basis for Edwin's·engraving. Peale's biographer Charles Coleman Sellers believes this memorial print may represent an allegorical work by Peale's son Rembrandt which was exhibited repeatedly in the first years of the nineteenth century. On July 3, 1808, the elder Peale wrote his son, then in France, of the transparency:

I wish the 4th may not be spent in too much free living, for great preparations of parade will then take place. I shall put up the

Apotheosis of General Washington and the portrait of Mr. Jefferson with the motto "Peace to the World" for the evening entertainment.[1]

In this design, Washington rides clouds to the heavens above Mount Vernon and receives the wreath of immortality from a cherub at upper left. Although Sellers identifies the hero's heavenly companions as Martha Washington and John Parke Custis, a description in the New York *Mercantile Advertiser* of December 20, 1800, names them as deceased Generals Warren and Montgomery.[2]

1. Quoted in Sellers, "Charles Willson Peale with Patron and Populace," 33, S82.
2. Quoted in Deutsch, 328, fig. 11.

18. **John (Johann) Eckstein.** American, born Germany, c. 1736–1817

To the Honorable Society of the Cincinnati: This Monument of Genl. George Washington. 1806
Stipple engraving. Sheet: 27 x 20½ in. (68.6 x 52.1 cm.)
Inscribed at bottom: *Design'd Engrav'd & Publish'd by John Eckstein Philada./To the HONORABLE the Society of the CINCINNATI:/this Monument of GENL. GEORGE WASHINGTON:/Is very respectfully inscribed by the/Artist/ Copyright secured according to Law;* upon tablet on pedestal: *FIRST IN WAR/FIRST IN PEACE/AND/FIRST IN THE HEARTS OF HIS COUNTRY*

Stanley Deforest Scott

PROVENANCE
Old Print Shop, New York; to Stanley Deforest Scott, 1974
EXHIBITION
New York, 1976
LITERATURE
Baker 401; Hart 770; Stauffer 687.

Eckstein, sculptor as well as engraver, modeled in 1806 a statue of Washington in the *ad locutio* pose for a proposed monument. Stauffer explains that this print is the artist's engraved version of that design issued for the Society of the Cincinnati in the same year.[1]

1. Stauffer I, 74–75.

19. **J. P. Elven.** English, late 18th–early 19th century
after
H. Singleton. American, active last quarter of 18th century(?)

Washington Giving the Laws to America
Line engraving. Sheet: 20 x 14 in. (50.8 x 35.6 cm.)
Inscribed: *Washington Giving the Laws to America;* upon tablet in Washington's right hand: *THE/AMERI/CAN CONSTI/TU/TION*

Prints Division, The New York Public Library, New York City. Astor, Lenox, and Tilden Foundations

PROVENANCE
Charles Williston McAlpin; to New York Public Library, 1942
EXHIBITION
Washington, D.C., 1976, 8, repro.

18

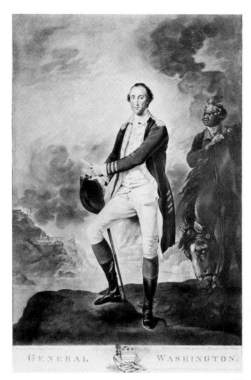

20

Figure 12. *Patriotism* from George Richardson, *Iconology; Or a Collection of Emblematical Figures* . . . (London, 1779), Pl. 281. Vassar College Library.

LITERATURE
Hart 777*

20. **Valentine Green.** English, 1739–1832
after
John Trumbull. American, 1756–1843

General Washington. 1781
Mezzotint with hand coloring. Sheet: 25 x 16 in. (63.4 x 40.7 cm.)
Inscribed: *Painted by I. Trumbull Esqr. of Connecticut, 1780.—Engraved by V. Green Mezzotinto Engraver to his Majesty & the Elector Palatine./ GENERAL WASHINGTON./ Engrav'd from the Original Picture in the possession of M. De-Neufville, of Amsterdam.—Publish'd by Appointmt. of M. De-Neufville, Janry. 15th 1781, by V. Green, N. 29, Newman Street, Oxford Street, London.*

Stanley Deforest Scott

PROVENANCE
Kennedy Galleries, New York City; to Stanley Deforest Scott, 1969
EXHIBITION
New York, 1976
LITERATURE
Baker 147; Hart 84; Sizer, 81, fig. 91; A. T. E. Gardner and S. Feld, *American Paintings: A Catalogue of the Collection of the Metropolitan Museum of Art* I, 101; Jaffe, 314; S. W. Grote, "Engravings of George Washington in the Stanley Deforest Scott Collection," *Antiques* 112 (July, 1977), 131, fig. 12

This engraving was made after John Trumbull's portrait of 1780, now in the Metropolitan Museum of Art (fig. 13). Trumbull painted this full-length Washington from memory shortly after arriving at Benjamin West's studio in London. The figure bears a sharp resemblance to the personification of *Patriotism* (fig. 12) from Césare Ripa's *Iconology*, as illustrated and described in the 1779 English edition by architect George Richardson. In 1780, Trumbull would have found the newly-released *Iconology* very much in vogue among artists at the Royal Academy. Joshua Reynolds, Benjamin West, Edward Penny, George Romney, Paul Sandby, and Antonio Zucchi were among the painters who had subscribed to the lavishly illustrated volumes. Trumbull might easily have drawn from the engraving and explanation of *Patriotism* contained therein a fitting form for General Washington. According to the text, the emblem was expressed by:

> . . . the figure of a robust warriour dressed in armour, and treading upon weapons of war; he is standing on the brink of a precipice, and is situated between a burning flame and a cloud of thick smoke, arising from a gulf. He holds a crown of laurel in his right hand, and in the left, a garland of oak leaves. He is dressed in armour, to denote the usefulness of the art of war to a country; and stands on the brink of a precipice, trampling on the weapons of war, to indicate that persons of this character fear no danger when engaged in the country's cause, and that their courage surmounts every difficulty. He is situated between a flame and a cloud of smoke, to justify the old proverb. . . "The smoke of our native

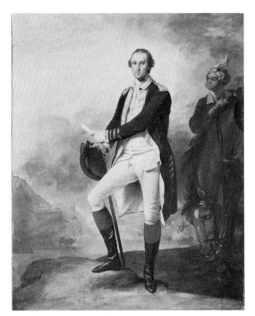

Figure 13. John Trumbull, *George Washington*, 1780; oil on canvas. Metropolitan Museum of Art, New York.

country appears more shining than the fire of another country. . . ." The crown of laurel, and garland of oak in his hands, allude to the rewards and honorary distinctions conferred on the Roman generals and citizens, for saving their country from imminent dangers.[1]

Like Ripan *Patriotism,* Trumbull's *Washington* pauses upon the brink of a precipice, while the fire and smoke of America's fighting with Britain rise from the gulf behind him.

Green's popular mezzotint was the source for English copperplate-printed textile images of Washington in imperial apotheosis (37 and 38).

1. George Richardson, *Iconology; Or a Collection of Emblematical Figures . . .* (London, 1779), II, Book Third, 53, fig. 281.

21. **Valentine Green.** English, 1739–1832
after
Charles Willson Peale. American, 1741–1827

George Washington. 1785
Mezzotint. Sheet: 19½ x 13⅞ in. (49.6 x 35.3 cm.)
Inscribed: *J. Brown Excudit./ Peel pinxit, Philadelphia./ Stothard delint. Londini/—V. Green fecit Mezzotinto Engraver to the King of Great Britain and/ the Elector Palatine./ GENERAL WASHINGTON./ From an Original Picture in the Possession of Mr. Brown. Publish'd by him April 22d 1785, and Sold at No. 10, George Yard, Lombard Street, London.*

National Portrait Gallery, Smithsonian Institution, Washington, D.C.
LITERATURE
Baker 12; Hart 18; Morgan and Fielding, 34, no. 25; "The Cover," *Antiques* XXXV (February, 1939), 63; NPG *Illustrated Checklist,* 130

Green's version of the 1779 portrait by Charles Willson Peale (fig. 2) was probably engraved after a replica by Thomas Stothard (1755–1834), English painter and illustrator and Royal Academician. The salient features of the Green-Stothard portrait are indeed those of Peale's *Washington* after the battle of Princeton: Nassau Hall, Princeton College is evident in the background, as is a group of Hessian soldiers held captive. General Washington, resting upon a cannon, wears the Continental uniform of dark blue coat with buff-colored facings and waistcoat over white knee breeches. Stothard made significant changes in the figure, however, which suggests that the artist was following a Reynoldsian fashion and rendered Washington to conform to Ripan personification of *Virtue*. *Virtue* was described in George Richardson's 1779 edition of the *Iconology* thus:

VIRTUE, or moral excellence, is represented by the figure of a very graceful young woman with steady countenance, dressed in white robes, with wings at her shoulders, and the figure of the refulgent sun on her breast. She is resting on a square stone, holding a spear in her right hand, and in the left a sceptre, with garlands of palm and laurel, and a corselet round her body. She is represented young and graceful, of a modest and stately countenance, to denote that Virtue is the greatest beauty and ornament of the mind, and expressive of humility, peace, and permanent happiness. The white robes are emblematical of purity, sincerity, honesty, uprightness, and in general of every moral

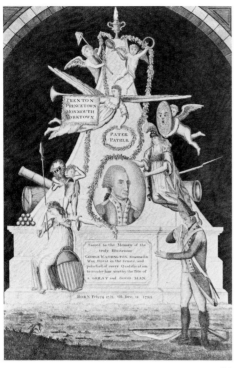

22

goodness. The wings at her shoulders indicate the exalted sentiments of Virtue and her superiority in soaring above the unruly passions. . . . The square stone alludes to solidity, truth and intellectual strength; and the spear, sceptre and garlands with a corselet round her body, signify valour, power, authority, victory, and the reward due to virtuous and meritorious actions, and that she is always defended against the assaults of vice.[1]

Similarly, a handsome, graceful Washington leans upon a cannon, which likewise connotes strength, at left. His riding crop is a conspicuous compositional device forming an oblique implied line extending from the toe of Washington's boot to the winglike epaulette of his right shoulder, much like the long lance in *Virtue's* grasp. Even the white of the General's uniform implies the purity of *Virtue* (fig. 3).

Green was a subscriber to Richardson's *Iconology*, as was the Royal Academy. Hence, both Stothard and the engraver no doubt knew well the attributes of this specific personification described therein.

1. George Richardson, *Iconology; Or a Collection of Emblematical Figures. . .* (London, 1779), II, Book Fourth, 155–56, fig. 415.

22. **Enoch Gridley.** American, active 1800–1818
after
John Coles, Jr. American, 1776 or 1780–1854

Mourning Piece for George Washington. 1810; first state 1800
Engraving. Sheet: 13⅛ x 8¾ in. (33.2 x 22.5 cm.)
Inscribed at bottom: *Painted by John Coles, Jun.—Engd. by E. G. Gridley.;* upon tomb tablet at center: *Sacred to the Memory of the/Truly Illustrious/ GEORGE WASHINGTON, Reknowned in/ War, Great in the Senate, and possessed of every Qualification to render him worthy the Title of/ a Great and Good Man.;* upon base of tomb: *Born Feb. 22. 1732. OB Dec. 14. 1799.;* upon banner at center: *TRENTON/ PRINCETOWN/ MONMOUTH/ YORKTOWN;* within laurel wreath, at center: *PATER/ PATRIAE*

National Collection of Fine Arts, Smithsonian Institution. Museum Purchase 1971

EXHIBITIONS
Washington, D.C. National Collection of Fine Arts, Smithsonian Institution, *A Measure of Beauty: The Diffusion of Style in Early Nineteenth Century America,* 1973; Washington, D.C., 1976, 31

LITERATURE
Baker 403; Hart 221; Stauffer 1184; Dreppard, 97; Schorsch 14, fig. 23; Deutsch, 325

A broadside published in Boston, March 13, 1801, described Gridley's already popular memorial print:

1st. An high finished white marble *Monument*, rising in a pyramidical form.

2d. On the left of the Piece, a *war-worn Veteran*, with his arms grounded, in awful surpriz at the sight of his General's Funeral Pire; with his right hand he wipes the falling tear; and with his left he motions his distress of mind. In the Person of the *war-*

worn Veteran, you behold a lively representation of the Grief of all the *Army* of *America,* for the loss of their beloved *General* and *Commander* in *Chief.*

3d. The Genius of *Columbia,* on the right reclining on her Spear erect in her right hand; and her left responsive to her deep distress. In the Genius of *Columbia,* you see a lively Emblem of the Grief of all *America,* for the loss of the *Father* of his *Country.*

4th. *Minerva* retires from her Shield, and seated near the Trophies of War, presents and supports the LIKENESS of the *departed Hero.* As *Minerva* is called the Goddess of *Wisdom,* in the heathen Mythology; and she supports his likeness, it shows in the Design, that he was always supported by Wisdom, in all his Measures and Transactions. In the Goddess *Minerva* you see *Wisdom* grieving for the loss of one of the wisest *Men* of the *Age.*

5th. The Genius of *Mars* approaches with the Helmet of Defence; but finding the General is no more is stunned with surprise. In the Genius of *Mars,* you behold *Valour* and *Courage* grieving for the greatest *Hero* of the *Age.*

6th. The Genius of *Minerva,* attending with the Shield of the Gorgon head. As this is the Shield of *Minerva,* it supposes in the Design, that he was shielded by Wisdom in all his Difficulties and Dangers.

7th. *Fame,* with wings expanded, holding the Trump, on the Banner of which is inscribed the Names of those places where *Signal victories* have been obtained; and in her left hand a Wreath, enclosing the word *Pater Patriae.* You likewise see *Fame,* grieving for the most famous *Man* of the *Age.*

8 & 9. The Genii of *Liberty* and *Truth,* with their Emblems, both assisting to adorn his brow with Laurels; and on the top of the Pire, an *Urn,* blazing with the incense of *Memory* and *Love,* which will never be extinguished. And above, *Liberty* and *Truth,* grieving for the loss of the greatest *Supporter* they have had for several Ages past.[1]

Duetsch points out that the design may be based on the set of a mock funeral held in Burlington, New Jersey, probably on Washington's Birthday in the February following the hero's death. The *Trenton Federalist; or New Jersey Gazette* of March 10, 1800 reported on the spectacle thus:

. . . the eye. . . was surprized and delighted at the view of a beautiful obelisk, 15 feet high, erected on the stage prepared for the orator . . . at the top of the obelisk . . . is an inscription bearing the day of the General's death and his age. A figure of Fame is then represented with a trumpet to her mouth, and a flowing scroll in her hand, displaying the principal scenes of his battles and victories, Trenton, Princeton, Monmouth and York. Under these is a picture of the General, crowned with laurels and ornamented with the colours of the Union inverted, and other insignia of war. . . . The whole obelisk is painted to imitate marble, and the sable drapery which hung behind it, the profusion of gilding, and the judicious selection of colouring gave it a funeral cast truly melancholy and affecting.[2]

The portrait of Washington upon the tomb tablet is based on Edward Savage's life portrait of 1790 which Savage himself engraved in 1793.

1. From the collection of the Historical Society of Pennsylvania, Broadside AB 1801–5.

2. Quoted in Deutsch, 325.

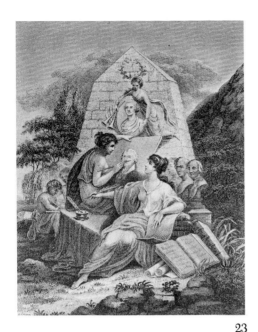

23

23. **Francis Kearney.** American, 1785–1837
after
Gideon Fairman. American, 1774–1827

American Literature and Fine Arts Rewarding Patriotism and Virtue, from *The Port Folio.* 1815
Engraving. Sheet: 9 x 5¹¹/₁₆ in. (22.9 x 14.4 cm.)
Inscribed: *G. Fairman designer—F. Kearney, sculp./ American Literature and Fine Arts Rewarding Patriotism and Virtue;* at center top: ALLEGORICAL

The Historical Society of Pennsylvania, Philadelphia. Baker Collection

EXHIBITION
Washington, D.C., 1976
LITERATURE
Stauffer 1571

24. **Thomas Kelly.** American, c. 1795–c. 1841

Washington's Reception on the Bridge at Trenton in 1789 from the *Columbian Magazine*
Engraving. Image: 5 x 7¼ in. (12.7 x 18.4 cm.)
Inscribed at bottom: *Engraved by T. Kelly/Washington's Reception on the Bridge at Trenton in 1789 on his way to be Inaugurated First President of the United States/ Designed Expressly for the Columbian Magazine by J. L. Morton;* upon festooning at top: *THE HERO WHO DEFENDED THE MOTHERS DECEM 26 1776 WILL PROTECT THE DAUGHTERS*

The American Antiquarian Society, Worcester, Massachusetts

LITERATURE
Fielding *Supplement* 834; Dreppard, 102

Washington received official notification of his election as President on April 14, 1789, when special messenger Charles Thompson, Secretary of Congress, arrived at Mount Vernon with word from the President of the Senate. Two days later, Washington said good-by to his homestead and began a journey— or, rather, a triumphal procession—to New York City, then seat of Federal Government. There, on April 30, the Inauguration would take place. Along Washington's route, in all the principal cities, the new leader was greeted with public displays approaching the great ancient civic celebrations of imperial apotheosis. Washington Irving, in his *Life of Washington,* tells of the glory paid the President-elect:

> Washington's progress to the seat of Government was a continual oration. The ringing of bells and roaring of cannonry proclaimed his course through the country. The old and young, women and children, thronged the highways to bless and welcome him. Deputations of the most respectable inhabitants from the principle places came forth to meet and escort him. . . .[1]

Few such demonstrations of regard received the notice accorded that at Trenton, New Jersey on April 21. There Washington was greeted by the city's mothers and daughters as the saviour of New Jersey womanhood—he who had driven the lecherous Hessians

out of that area during the Revolutionary War. The spectacle was described in detail by one celebrant:

> As Trenton had been rendered twice memorable during the war, once by the capture of the Hessians, and again by the repulse of the whole British army, in their attempt to cross the bridge over the Assanpinck Creek, the evening before the battle of Princeton—a plan was formed by a number of ladies and carried into execution . . . to testify to the General, by the celebration of these eventful actions, the grateful sense they retained of the safety and protection afforded by him to the daughters of New Jersey. For this purpose, a triumphal arch was raised on the bridge, about twenty feet wide, supported by thirteen columns—the height of the arch to the central was equal to the width. Each column was entwined with wreathes of evergreen. The arch, which extended about twelve feet along the bridge, was covered with laurel, running vines, and a variety of evergreens.
>
> On the front of the arch the following motto was inscribed in large gilt letters—"The Defender of the mothers will also protect the daughters"—The upper and lower edges of this inscription were ornamented with wreathes of evergreen and artificial flowers of all kinds, made by the ladies for the occasion, beautifully interspersed. On the center of the arch, above the inscription, was a dome, or cupola, of artificial flowers and evergreen, encircling the dates of those glorious events which the whole was designed to celebrate, inscribed in large gilt letters. The summit of the dome displayed a large sunflower, which, always pointing to the sun, was designed to express this sentiment or motto—"To you alone"—as emblematic of the affections and hopes of the people being directed to him, in the united suffrage of the millions of America.
>
> A numerous train of ladies, leading their daughters, were assembled at the arch, thus to thank their Defender and protector. As the General passed under the arch, he was addressed in the following *Sonata* composed and set to music for the occasion, by a number of young ladies, dressed in white, decked with wreathes and chaplets of flowers, and holding in their hands baskets filled with flowers:

WELCOME, mighty Chief! once more,
Welcome to this grateful shore;
Now no mercenary foe
Aims again the fatal blow—
Aims at thee the fatal blow.

Virgins fair, and Matrons grave
Those thy conquering arms did save,
Build for thee triumphal bowers.
Strew, ye fair, his way with flowers—
Strew your hero's way with flowers.[2]

This illustration from *The Columbian Magazine*, though not contemporaneous with the event, is a rare attempt at documenting in the visual arts the grand scale of such ephemeral displays.

The impact of this particular testimonial upon the ladies of Trenton is evinced in a painting by Stuttgart academician Philip Freidrich von Hetsch, whose *Homage to Washington* of 1793 probably commemorates the reception. H. W. Janson has suggested that this German work was commissioned by two of the Trenton maids in Europe on the Grand Tour. The subject is two female artists, one of whom draws a profile of Washington while her companion holds up a banderole inscribed *Trenton 21 April 1789*. The ladies sit before a funerary monument of the Fates, the base of which bears Washington's name and thus commits the President, who

was still alive at this date, to immortality.[3]

1. Washington Irving, *Student's Life of Washington* (New York, 1870), 639–40.
2. *The Pennsylvania Packet and Daily Advertiser* (May 1, 1789), from Society of Iconophiles, *Washington's Reception by the Ladies of Trenton . . . April 21st, 1789* (New York, 1903), 9–14.
3. See Hugh Honour, *The European Vision of America* (Cleveland, 1975), no. 223, n.p. H. W. Janson is cited therein.

25. **Robert Lowe.** American, active 1832–51

Sacred to the Memory of the Illustrious General George Washington. 1838
Engraving. Sheet: 28 x 22 in. (71.1 x 55.9 cm.)
Inscribed within oval of pen work: *"Born February 22nd 1732—Died December 14th 1799"*; text: *Sacred/ to the Memory of the/ Illustrious Champion of Liberty/ General—George/ Washington,/ First—President of the United States—of/ America./ Engraved by R. Lowe N. York./ Presented to—By—As a/ Reward of Merit./ (Copyright 1838 by Samuel Green)/ Published by John Donlevy N.Y.*

Prints Division, The New York Public Library, New York City. Astor, Lenox and Tilden Foundations

25

26

PROVENANCE
Charles Williston McAlpin; to New York Public Library, 1942
LITERATURE
Hart 862

Calligraphic samplers dedicated to Washington were a product of enduring didacticism in America's arts. Exercises in penmanship derived from popular belief in the moral content of prescribed forms. Training the eye to see those forms and disciplining the hand to create them were means to instruct the mind in the virtues of order. Moral and religious texts were inevitably incorporated into these drills, and, thus, exhortations to see the grace of God in Washington were appropriate themes for copiers seeking to understand the nature of beauty, goodness, and truth.

26. **Peter Maverick.** American, 1755–1811

Calligraphic Sampler: *Eulogium Sacred to the Memory of the Illustrious George Washington.* 1817
Engraving. Sheet: 16½ x 20¼ in. (41.8 x 51.5 cm.)
Inscribed, script surrounding composition: *Eulogium Sacred to the Memory of the ILLUSTRIOUS George Washington, COLUMBIA'S Great and Successful Son: Honored be his Name;* verse at center: *"Tho' shrin'd in dust, great WASHINGTON now lives,/ The Memory of his Deeds shall ever bloom;/ Twin'd with proud laurels, shall the Olive rise,/ And wave unfading o'er his Honor'd Tomb./ To him ye Nations yield eternal FAME,/ First on th'Heroic list enroll his Name;/ High on th'ensculptured marble let him stand,/ The undaunted Hero of his native land;* text: *SPIRIT OF SYMPATHY! from Heaven descend!/ A NATION weeps, Columbia mourns a Friend./ O! ne'er to man did bounteous Heaven impart/ A purer spirit, a more gorgeous heart./ And in that Heart, did Nature sweetly blend,/ The fearless Hero and the faithful Friend./ As some fond mother who rewards her child,/ and vents her grief in mournful accents wild;/ So look'd COLUMBIA'S GENIUS when stern Death,/ Relentless Tyrant, snatch'd her fav'rite's breath./ Now from the regions of Eternal Light,/ To where thy 'scent has winged its joyful flight./ Witness the tears that for thy loss do flow,/ Behold a Nation whelm'd in silent woe:/ The pearly drops which tremble in each eye,/ shall sooth thy spirit thron'd above the sky./ BLEST SHADE! Farewell! thy Memory ever dear,/ Oft shall receive fair Freedom's holy tear;/ In each fond heart shall live thy peerless Name,/ And there shall rise thy MONUMENTS of FAME.";* in border surrounding portrait: *SACRED TO THE MEMORY OF THE BRAVE:* upon pedestal tablet: *Gen. George/WASHINGTON/ departed this life/ Decr. 14th 1799–AE 67./ And the tears of a/ NATION/ watered his/grave;* upon pedestal: *Washington's memory, by silence grief's express'd/ Lo! here he lies, his Works proclaim the rest./* lower left: *DESIGNED/ Written/ AND/ PUBLISHED;* lower right: *by/ BENJAMIN O. TYLER./ Professor of/ Penmanship./ NEW YORK./ 1817.;* at bottom: *Engraved by P. Maverick.—Newark, N. Jersey./ Penmanship in all the Ancient and Modern hands taught on an improved System (entirely his own) by Benjamin Owen Tyler, at No. 126 Broadway opposite*

City Hotel. N. York.; upper left: *VIVE LA PLUME:* upper right: *VIVA NOMEN.*

The American Antiquarian Society, Worcester, Massachusetts

LITERATURE
Baker 404; Hart 796b; Stauffer 2232; S. D. Stephens, *The Mavericks, American Engravers* (New Brunswick, New Jersey, 1950), no. 767

27. **John B. Neagle.** American, born England, c. 1796–1866
after
Thomas Sully. American, 1783–1872

Certificate of the Washington Benevolent Society of Pennsylvania
Line engraving. Sheet: 22 x 28 in. (55.9 x 71.1 cm.)
Inscribed upon book at extreme lower right: *T.S.*

Prints Division, The New York Public Library, New York City. Astor, Lenox and Tilden Foundations

PROVENANCE
Charles Williston McAlpin; to New York Public Library, 1942
LITERATURE
Hart 771; Stauffer 2313

27

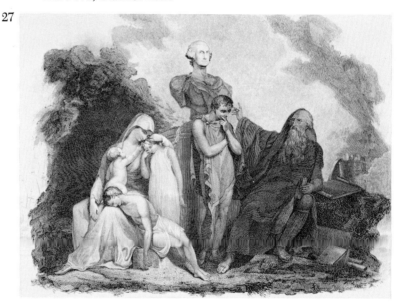

28

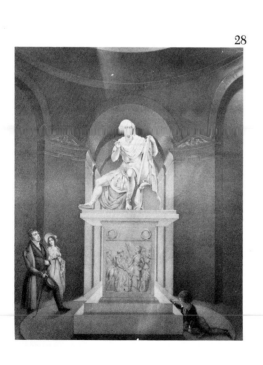

28. **Albert Newsam.** American, 1809–64
after
Joseph Weisman. American, active 1822–24
and
Emanuel Leutze. American, born Germany, 1816–68

Lafayette in 1825 Viewing Canova's Statue of Washington. 1840
Lithograph. 30½ x 23¾ in. on wood stretcher (77.5 x 60.3 cm.)
Inscribed: *J. Weisman & Leutze, pinxt—Drawn on stone by A. Newsam—P.S. Duval, Lith, Phila./ CANOVA'S STATUE/of/*

GENERAL GEORGE WASHINGTON/ As it appeared on the Pedestal, in the State House Rotunda, at Raleigh, North Carolina/ A beautiful light falling from the Dome Window, upon the slab of marble, illuminates the whole statue. Lafayette is represented viewing this masterly representation of his beloved General/ Respectfully dedicated to the Legislature of North Carolina by J. Weisman/ Entered according to Act of congress in the year 1840, by J. Weisman, in the Clerk's Office of the District Court of the Eastern District of Pa.

North Carolina Museum of History. Gift of Former Governor Charles B. Aycock

EXHIBITIONS
Providence, 1976, no. 19; Raleigh, North Carolina Museum of Art, *200 Years of Visual Art in North Carolina,* 1976

LITERATURE
Q. de Quincy, *Canova et ses ouvrages* (Paris, 1834), 301–5; R. D. W. Connor, "Canova's Statue of Washington," *North Carolina Historical Commission Bulletin* 8 (1910), illus. op. 30; Whittemore, pl. VII; H. Honour, *The New Golden Land* (New York, 1975), 156–57, fig. 153b.

This lithograph is a tribute to the famous monument to Washington sculpted in 1820 by Italian artist Antonio Canova (1757–1822) for the North Carolina State House in Raleigh. Fire destroyed the statue in 1831, and the Leutze-Weisman figure is a reconstruction made after the disaster.

When in December, 1815, the General Assembly of North Carolina voted to commission a full-length statue of Washington for the hall of the State Senate, aesthetes from all across the new country took an interest in the project. Thomas Jefferson, convinced that no native sculptor could prove competent to do work worthy of Washington, urged the appointment of Canova to the task:

> I do not know that there is a single marble statuary in the U.S., but I am sure there cannot be one who would offer himself as qualified to undertake this monument of gratitude and taste. . . .
>
> . . . Who should make it? There can be but one answer to this. Old Canove of Rome. No artist in Europe would place himself in a line with him; and for 30 years, within my own knowledge, he has been considered by all Europe as without a rival.[1]

Jefferson further advised that Washington be represented as a noble Roman:

> . . . As to the style or costume, I am sure the artist, and every person of taste in Europe would be for the Roman, the effect of which is undoubtedly of a different order. Our boots and regiments have a very puny effect.[2]

To that end Guiseppe Ceracchi's apotheosized bust (see no. 35), made from life, served as model for the face.

Commemorating Washington's retirement from politics at the end of his second term of office, Canova portrayed the President in the act of renouncing his civil authority. On a large tablet in his left hand, Washington inscribes his farewell address. Allusion to Cincinnatus is indeed manifest here, but the American public might just have easily associated the scene with Moses and the book of

Deuteronomy. The Italian Countess Albrizzi, in her *Works of Antonio Canova*, implied such an association when she described the *Washington:*

> The hero is in the act of writing on a tablet held in his left hand. . . . From the following words already inscribed on it, we learn the subject which occupies his mind—"George Washington to the people of the United States—Friends and Fellow Citizens." In his right hand he holds the pen with a suspended air, as if anxiously meditating on the laws fitted to promote the happiness of his countrymen. . . .[3]

Leutze and Weisman have depicted the reverence with which Lafayette's visit to the ill-fated statue in March, 1825, was invested. Lafayette is absorbed in contemplation. A child sketching at the base of the monument further heightens the unity of action, for the onlookers are solely intent on the work of art. One may speculate that the Frenchman's thoughts at this moment must have echoed those of that enthusiastic admirer of Canova, the Countess, who found the *Washington* a virtual transfiguration:

> If to this great man a worthy cause was not wanting, or the means of acquiring the truest and most lasting glory, neither has he been less fortunate after death, when, by the genius of so sublime an artist, he appears again among his admiring countrymen in this dear and venerated form; not as a soldier, though not inferior to the greatest generals, but in his loftier and more benevolent character of the virtuous citizen and enlightened lawgiver.[4]

1. Letter from Thomas Jefferson to North Carolina State Senator Nathaniel Macon, January 22, 1816, quoted in R. D. W. Connor, "Canova's Statue of Washington," 23.
2. *Ibid.*, 24.
3. Quoted *Ibid.*, 10.
4. *Ibid.*, 11.

29. Attributed to **John Norman.** American, born London, c. 1748–1817

The True Portraiture of his Excellency George Washington, Esquire in the Roman Dress. 1783
Etching. Sheet: 20 x 14 in. (50.8 x 35.6 cm.). Image: 13 x 9¹/₁₆ in. (33.1 x 23.1 cm.)
Inscribed: *The true PORTRAITURE of his Excellency/ George Washington Esq./ In the Roman Dress, as ordered by Congress for the Monument to be erected/ in Philadelphia, to perpetuate to Posterity the Man who commanded the/American forces through the late glorious Revolution.*

Prints Division, The New York Public Library, New York City. Astor, Lenox, and Tilden Foundations

PROVENANCE
Charles Williston McAlpin; to New York Public Library, 1942
LITERATURE
Baker 426; Hart 45

On August 7, 1783, Congress voted to erect in Philadelphia an equestrian statue of Washington, "the general to be represented in a roman dress, holding a truncheon in his right hand and his head encircled with a laurel wreath".[1] The inscription indicates that this figure is a design for that proposed monument.

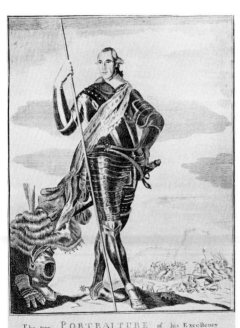

The true PORTRAITURE of his Excellency
George Washington Esq.
In the Roman Dress, as Ordered by Congress for the Monument to be erected
in Philadelphia, to perpetuate to Posterity the Man who commanded the
American Forces through the late glorious Revolution.

29

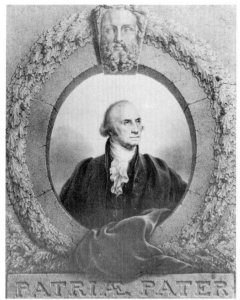

30

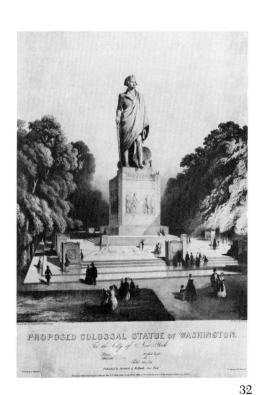

PROPOSED COLOSSAL STATUE OF WASHINGTON.

32

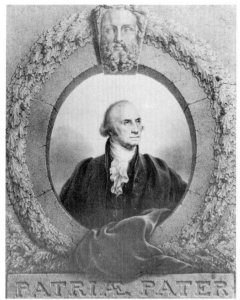

Hart notes that this figure is drawn from a portrait of Sir William de la Mose, in *Guillem's Heraldry* (London, 1679).

1. Hart, 25.

30. **Rembrandt Peale.** American, 1778–1860

George Washington. 1827
Lithograph. Sheet: 24 x 17¾ in. (61 x 45.2 cm.)
Inscribed: *Washington/ Drawn on Stone by Rembrandt Peale. Copyright secured 1827. Pendleton's Lithography, Boston./ From the Original Portrait by Rembrandt Peale; Patriae Pater* incorporated into design on simulated stone surround

The Historical Society of Pennsylvania, Philadelphia

LITERATURE
Dunlap II, 188; J. A. Mahey, "Lithographs by Rembrandt Peale," *Antiques* 97 (February, 1970), 236–42

31. **John Rogers.** American, c. 1808– c. 1888
after
James C. Thom(?). American, 1835–98

The American Eagle Guarding the Spirit of Washington from *Cosmopolitan Art Journal,* June, 1859
Engraving. Image: 10¼ x 7¹³/₁₆ in. (25.9 x 18.3 cm.)
Inscribed: *Thom—Rogers./ The American Eagle/ Guarding the Spirit of Washington/ Dedicated to Mount Vernon Association/ By the Cosmopolitan Art Association*

The New York Historical Society, New York City

LITERATURE
Hart 201; Thistlethwaite, 200, fig. 170

32. **George H. Thomas**(?). American, 1824–68
after
Thomas Crawford. American, 1814–57
and
Frederick Catherwood. American, born London, 1799–1854

Proposed Colossal Statue of Washington. 1845
Lithograph. Sheet: 21¼ x 15½ in. (54 x 39.4 cm.)
Inscribed: *Designed by Thos. G. Crawford & F. Catherwood/ on stone by G. Thomas/ PROPOSED COLOSSAL STATUE OF WASHINGTON./ For the City of New York./ Statue . . . 75 feet high./ Pedestal . . . 55./Total 150 feet/ Published by Bartlett & Welford, New York/ Printed by F. Michelin 14 Nassau St. N. York./ Entered According to Act of Congress in the year 1845 by F. Catherwood, in the Clerk's Office of the District Court of the Southern District of N. York.*

The New York Historical Society, New York City

LITERATURE
Barck, 84, illus. frontispiece

In 1843 the Washington Memorial Association of New York City was organized to plan, raise subscriptions, and bring about the erection of a suitable public memorial to the Father of his Country.

Among the designs submitted to Association President, artist John Trumbull, was a monumental figure by sculptors Thomas Crawford and Frederick Catherwood. A Washington standing seventy-five feet tall surmounted a pedestal fifty-five feet high, according to the Crawford-Catherwood proposal. An idealized Washington in military dress would also wear the toga of Roman civic leaders and hence, in scale and iconography, would resemble declamatory monuments of apotheosized leaders of the ancient republic. The grand scheme was never executed, although this lithograph was issued to promote the design and encourage donations.

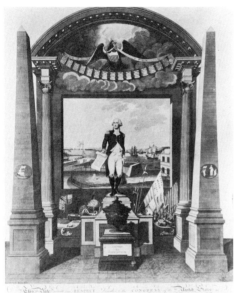

33

33. **Cornelius Tiebout.** American, c. 1773–1832

Sacred to Patriotism. second state 1798
Line and stipple engraving. Sheet: 27¼ x 22¼ in. (69.2 x 56.5 cm.)
Inscribed at bottom: *Drawn by Charles Buxton, M.D.— C. Tiebout sc./ This Plate is with due Respect Inscribed to the Congress of the United States, by/ Chas Smith.—New York. Published by C. Smith, 1798;* upon open scroll in statue's right hand: *Friends and Fellow Citizens;* upon urn at center: *Sacred to Patriotism;* upon shaft at left: *Liberty;* upon shaft at right: *Independence;* upon banderole at top: *E Plur Unum;* and sixteen banners respectively inscribed: *TENNESSEE — GEORGIA — NORTH CAROLINA — SOUTH CAROLINA — KENTUCKY — VIRGINIA — MARYLAND — CONNECTICUT — RHODE ISLAND — MASSACHUSETTS — NEW HAMPSHIRE — VERMONT*

Fraunces Tavern Museum, Sons of the Revolution in the State of New York. Gift of Stanley Deforest Scott

LITERATURE
Baker 407; Hart 676; Stauffer 3196; Stokes, *Iconography*, 413, pl. 52

34

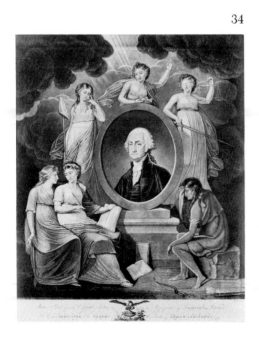

In the classical tradition, Washington is frequently depicted in the *ad locutio* posture which signals imperial apotheosis in Roman reliefs and declamatory monuments. The three-quarter profile and the short, quick motion of an oratorical gesture were conventions employed by antique sculptors in order to distinguish the figure of the emperor from his subjects in narrative compositions, and to render his person and his action more conspicuous and arresting. The hero's frontality and outstretched right arm, which interrupts the closed contours of his form, become a direct summons to the outside observer to take notice of this powerful figure. His hand, extended in the oratical gesture of supreme authority, gives visual evidence of his protectorate. American artists knew the motif from studying illustrated texts on imperial sculpture, coins, and gems, of which Bartoli's engraving of an apotheosized Augustus is an example (fig. 13).

Tiebout's design further commemorates a specific event of November 25, 1783, when British troops evacuated New York City. Fort George is a prominent landmark. Also highlighted is a pedestal on the Bowling Green from which a statue of George III was toppled by patriots on July 9, 1776. That sculpture was re-

placed by a polychromed wooden statue of Washington, upon which Tiebout's figure is based.

34. **William Wooley.** American, born England, active c. 1797–c. 1825

Dedicated to the Memory of His Excellency George Washington Esqr.
Mezzotint. Sheet: 23 x 19⅝ in. (58.4 x 48.7 cm.)
Inscribed at bottom: *David Longworth Direxit./ Wooley—Pinxit et Sculpsit./ This Print from the Original Picture in—the Possession of Longworth and Wheeler/ Is by them DEDICATED to the memory of—HIS EXCELLENCY GEO +WASHINGTON Esqr./ Published at the SHAKESPEARE GALLERY No 11 Park, N. York.*

Stanley Deforest Scott

EXHIBITION
New York, 1976
LITERATURE
Hart 467; Taylor, 34; S. W. Grote, "Engravings of George Washington in The Stanley Deforest Scott Collection," *Antiques* 112 (July, 1977), 134, fig. 20

SCULPTURE

35. **Alonzo Blanchard.** American, active mid-19th century

George Washington Ornamental Figure. Patented 1843
Cast iron. Height 46½ in. (118.1 cm.)
Inscribed: *Design Patent*

James Abbe, Jr.

EXHIBITION
New York, Washburn Gallery, *19th Century American Folk Art*

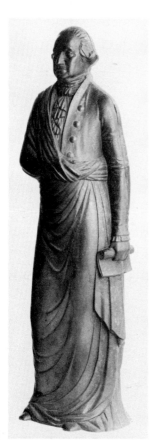

35

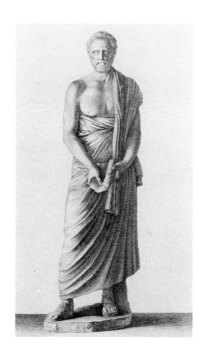

Figure 14. *Demosthenes* from Johann Joachim Winckelmann, *Histoire de l'art chez les anciens* . . . (Paris, Chez H. J. Jansen et compe., 1790–1803), II Pl. X. John Hay Library, Brown University.

From the Collection of James Abbe, Jr., 1979

LITERATURE

C. P. Hornung, *Treasury of American Design* (New York, 1972), 794, fig. 2815

Classical *gravitas* was manifested in the ancient togated figure, whose drape dematerialized the body while it heightened the iconic image of civil authority. This togated Washington, an ornamental figure intended, perhaps, for the top of cast iron heating stoves, resembles such an iconic image, an ancient sculpture of Demosthenes (fig. 14), Greek orator and political leader of the fourth century B.C., with whom many American statesman were compared in sculpture in the middle of the nineteenth century.[1]

Ornamental figures frequently adorned elaborately decorated cast iron stoves. Perhaps the first American to top a heating device with a classical Washington was Charles Willson Peale who, in 1798, published a design for a smoke-eating stove which he crowned with a bust of, presumably, *Pater Patriae*.[2]

1. See John Stephens Crawford, "The Classical Orator in Nineteenth Century American Sculpture," *The American Art Journal* 6 (November, 1974), 56–72.

2. Sellers, "Charles Willson Peale with Patron and Populace," 32, S81, 34, illus. 95.

36. **Giuseppe Ceracchi.** Italian, 1751–1801

George Washington. 1795
Marble. 28⅞ x 23¼ x 12 in. (73.3 x 59.1 x 30.5 cm.)
Inscribed on reverse: *Ceracchi faciebat Philadelphiae 1795*

The Metropolitan Museum of Art, New York City. Bequest of James L. Cadwalader, 1914

PROVENANCE

Josef de Jaudenes y Nebot, Cadiz, Spain, c. 1795–1812; purchase, Richard W. Meade, Philadelphia, c. 1812–28; Mrs. Richard W. Meade, 1828–52; Gouverneur Kemble, Cold Spring, New York, 1852–75; Kemble Estate, 1875–1904; purchase, John L. Cadwalader, 1904–14; to Metropolitan Museum of Art, 1914.

EXHIBITIONS

New York, National Academy of Design, *Mrs. Richard W. Meade's Collection of Paintings,* 1831; New York, American Art Union, *Washington Exhibition in Aid of the New York Gallery of Fine Arts,* 1853; New York, Metropolitan Opera House Assembly Rooms, *Centennial Celebration of the Inauguration of George Washington,* 1889; Philadelphia, Philadelphia Museum of Art, *Philadelphia: Three Centuries of American Art,* 1976, no. 139; Athens, National Pinathiki, Alexander Sontzos Museum, *Treasures from the Metropolitan Museum: Memories and Revivals of the Classical Spirit,* 1979

LITERATURE

G. I. Montanari, *Della Vita e Delle Opere di Giuseppe Ceracchi, Scultore Romano* (Rimini, 1841), 19; Dunlap, I, 405 and II, 462; Elizabeth Bryant Johnston, *Original Portraits of Washington* (Boston, 1882), 170; Morgan and Fielding, 209, no. 1; Whittemore, pl. VI; A. T. E. Gardner "Fragment of a Lost Monument," *Metropolitan Museum of Art Bulletin* VI (March, 1949),

189–97; U. Desportes, "Giuseppe Ceracchi in America and his Busts of George Washington," *Art Quarterly* XXVI (1963), 149–79; G. Hubert, *Les Sculpteurs Italiens en France sous la Revolution l'Empire et la Restauration* (Paris, 1964), 27, n.l.; U. Desportes, "Great Men of America in Roman Guise," *Antiques* 96 (July, 1969), 72–75

Of the Italian's work in this country, William Dunlap tells us:

> An ardent lover of the rights of man, Ceracchi conceived the design of erecting a monument to Liberty in the United States of America, and for this purpose crossed the Atlantic. In 1791 he arrived in Philadelphia, and prepared the model of a great work, designed to be one hundred feet in height, of statuary marble, and the cost was estimated at thirty thousand dollars.[1]

Statues of Revolutionary War heroes were to grace Ceracchi's monument, and the sculptor invited many of them to sit to him. Washington sat for the sculptor on two occasions—in 1791, when a terra cotta portrait bust was taken, and again in 1795, when revisions were made. Like many of his contemporaries, no doubt, Dunlap regarded the Romanized *Washington* as ". . . a beautiful piece of art and faithful portraiture, which is (with the exception of Gilbert Stuart's original painting, now in the Athenaeum in Boston) the only true portrait of our hero."[2]

Ceracchi's imperial *Washington*, with his nonspecific gaze symbolic of apotheosis, and wearing the diadem of his antecedents in antiquity, recalls portrait busts of Roman emperors.[3] Ceracchi knew such images firsthand, for he had been employed by the Pope, along with Antonio Canova, to design and execute sculpture for the Pantheon in the years before his brief trips to the United States. That Washington was flattered by Ceracchi's portrayal is evinced in the President's enthusiastic support for the costly, and therefore rather unpopular monument project, for which he entered into a promotional scheme with the artist and donated subscription funds. Moreover, the American public's predilection for an idealized, apotheosized Washington is indicated by the fact that Washington's private secretary and close confidant, Tobias Lear, owned a second version of the Ceracchi bust.[4]

Poor and broken from the failure of his plan for a shrine to liberty and equality, Ceracchi left America for Revolutionary France in about 1795. There he gave his life to the libertarian cause a few years later, but not before effecting his own apotheosis. Dunlap describes the details:

> . . . he became so violent a partisan and so desperate that he was condemned to death, as the leader of the conspirators connected with the infernal machine contrivance; and was guillotined in Paris in 1801—Ceracchi continued so frantic to the last that he actually built himself a car, in which he was drawn to the place of execution in the habit of a Roman Emperor. David, the French painter, with whom Ceracchi had lived in intimacy, was called to speak to his character; but he declared he knew nothing of him beyond his fame as a sculptor.[5]

1. Dunlap, II, 90.

2. *Ibid.*

3. H. P. L'Orange, *Apotheosis in Ancient Portraiture* (Oslo, 1947), cf. fig. 61, Gallienus.

4. The White House Collection, 817.1434.

5. Dunlap, 90.

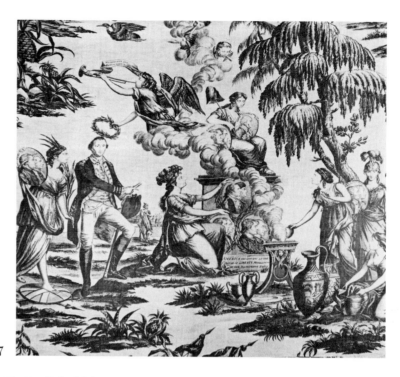

37

TEXTILES 37. English, 18th century

Bedhanging: *America Presenting at the Altar of Liberty Medallions of Her Illustrious Sons.* c. 1785
Copperplate-printed cotton. 92 x 95 in. (235.7 x 243.3 cm.)
Inscribed beneath altar of Liberty: *AMERICA presenting at the/Altar of LIBERTY Medallions/of her Illustrious Sons.*

The Daughters of the American Revolution Museum, Washington, D.C.

EXHIBITIONS
Washington, D.C., DAR Museum, *History in Printed Textiles*, 1975; Washington, D.C., DAR Museum, *The Decorative Arts in America at 1776*, 1976; Washington, D.C., DAR Museum, *George Washington: Image for a New Nation*, 1979

PROVENANCE
Charlotte Lee, Ballston Spa, New York; Margaret Lee Powell, Ballston Spa, New York; to Mrs. Thomas C. Luther, Saratoga Springs, New York; to Daughters of the American Revolution Museum, 1962

LITERATURE
E. Donnell, "Portraits of Eminent Americans after Drawings by DuSimitiere," *Antiques* (July, 1933), 17–21; J. Boicourt, "The Collector's Washington," *Antiques* (February, 1953), 125–27; E. A. Standen, "English Washing Furnitures," *Metropolitan Museum of Art Bulletin* XXIII (November, 1964), 122, fig. 14; E. M. Fleming, "From Indian Princess to Greek Goddess: The American Image 1783–1815," *Winterthur Portfolio* III (1967), 48; F. Montgomery, *Printed Textiles: English and American Cottons and Linens, 1700–1850* (New York, 1970), 280;

E. Donaghy, "French and English Decorative Arts in the Service of Seven American Kings," *Washington Antiques Show Catalogue* (January, 1973), 55–59, fig. 8; S. S. Tinkham, "DAR Museum Bicentennial Exhibition 'Up,'" *Antiques Monthly* (April, 1975), 3B, fig. 2

The figure of Washington is that of Valentine Green's mezzotint after the 1780 Trumbull portrait. Medallions of the new nation's illustrious sons are taken from portrait engravings of famous Americans by Pierre Eugène du Simitière, Swiss artist, historian, and antiquarian who lived in Philadelphia from 1766 until his death in 1784.

38. English, 18th century

The Apotheosis of Benjamin Franklin and George Washington. c. 1790

Copperplate-printed cotton. 75½ x 30¾ in., mounted (215.7 x 78.8 cm.)

Inscribed upon scroll held by Franklin: *Where Liberty Dwells There is my country;* upon plaque held by allegorical figure of America in chariot drawn by Washington: *American/Independ/ance/1776;* upon streamer wound around tree: *Liberty Tree/* [upside down] *Stamp Act;* upon snake on flag carried by Indian: *Unite or Die;* upon temple: *Temple of Fame;* upon map held by putti: *Pen/silvan/ia/Virginia/N Carolina/S Carolina/Georgia/ The Atlantic Ocean.*

Metropolitan Museum of Art, New York City. Bequest of Charles Allen Munn, 1914

EXHIBITIONS
New York, Metropolitan Museum of Art, *George Washington: Icon for America,* 1975; New York, Staten Island Institute of Arts and Sciences, *George Washington: Icon for America,* 1975

LITERATURE
R. T. H. Halsey, "The Rooms of the Early Republic in the New American Wing," *Metropolitan Museum of Art Bulletin* XIX (September, 1924), 215–16; Metropolitan Museum of Art, *Benjamin Franklin and his Circle* (New York, 1936), no. 321; Metropolitan Museum of Art, *Handbook of the American Wing* (New York, 1942), 274; E. A. Standen, "English Washing Furnitures," *Metropolitan Museum of Art Bulletin* XXIII (November, 1964), 123, fig. 16; F. Montgomery, *Printed Textiles: English and American Cotton and Linens, 1700–1850* (New York, 1970), 282, fig. 300

From his room at a Carlisle inn, Don Manuel Espriella, the fictitious Portuguese traveler of English poet Robert Southey, wrote in his 1807 *Letters from England* this graphic description of his chamber furnishings:

My bed curtains may serve as a good specimen of the political freedom permitted in England. George Washington is there, represented driving American independence in a car drawn by leopards, a black Triton running beside them and blowing his conch—meant, I conceive, by his crown of feathers, to designate the native Indians. In another compartment, Liberty and Dr. Franklin are walking hand in hand to the Temple of Fame, where two little Cupids display a globe on which

America and the Atlantic are marked. The tree of Liberty stands by, and the Stamp Act reversed is bound around it. I have often remarked of the taste of the people for these coarse allegories.[1]

With noteworthy ease the correspondent interpreted the imagery of the all-over, single-color allegorical scene stamped upon the fabric of his bed curtains and coverlet, both items fashioned from copperplate-printed cottons conveniently launderable and hence called "washing furnitures" in the eighteenth century. That American heroes should be apotheosized on an English textile shortly after the War of Independence is curious, though not unconventional. On the Continent and in the British Isles, Europeans and Englishmen were enchanted with tales of the strange, portentous culture that was the United States. Americana proliferated as exotica in European literature and art throughout the eighteenth century. What is more, popular images of America as Indian Princess, as Miss Liberty, or as the statesmen which she nurtured became highly saleable, and in no market was the profit-taking more lucrative than in the self-conscious new nation. An

38

Figure 15. *Triumphus Germanicus M. Aurelius*, from Pietro Bartoli, *Admiranda Romanarum Antiquitatum* (Rome, 1693), Pl. 8. Hillyer Art Library, Smith College.

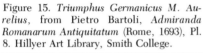

enterprising English copperplate textile industry, in competition with French printworks, realized capital gains rewarded the manufacture of Americana fabric prints for the new nation's drapers who habitually looked to the mother country for fine material goods. But no less than the United States populace did England and all Europe delight in images American, as Don Manuel Esprilla's chamber clothes clearly point out.

The object of the Portuguese traveler's report can be identified as this popular English copperplate pattern, *The Apotheosis of Benjamin Franklin and George Washington.* Many examples of the pattern in a variety of colors on both linen and copper weaves are known in this country and thus testify to the popularity of this English import in America. As early as 1784, only one year after the United States and Britain signed the Treaty of Peace, Baltimore dry goods dealers John Smith and Sons requisitioned "4 Pieces printed furniture in dark purple, Washington patterns,"[2] from Hadfield and Sons of Manchester, England. In 1785, Tommy Shippen, visiting the capital city, New York, detailed this copperplate pattern in an account of the President's house, then occupied by the youth's uncle, Richard Henry Lee, President of Congress:

> I find my uncle here in a Palace and think indeed that he does the honors of it, with as much ease and dignity as if he had been always crowned with a real diadem. My chamber is a spacious and elegant one and prettily furnished. I now write on it, and which way soever I turn my eyes I find a triumphal Car, a Liberty Cap, a Temple of Fame, or the Hero of Heroes, all these and many more objects of a piece with them, being finely represented on the hangings.[3]

The figure of Washington riding in a triumphal car is based on Valentine Green's mezzotint after the John Trumbull *George Washington* of 1780 (no. 21 and fig. 11), which the Connecticut artist painted from memory in London. Washington appears in the role of Roman victor, much like Marcus Aurelius, for example, who, in receiving his Senate's highest honor, was bedecked in a triumphal car and borne through the streets of the ancient republic, his victory both evidence of the man's achievement and demonstration of his right to rule. An engraving of *The Triumph of Marcus Aurelius* (after A.D. 177) appeared in Bartoli's *Admiranda Romanorum Antiquitatum* (Rome, 1693; fig. 15), a popular source book for neoclassical artists.

That Americans fully understood the classical iconography in this motif is indicated by a public spectacle held in Philadelphia on Independence Day, 1783, which demonstrated Roman triumph. The *Pennsylvania Journal* of July 5th reported:

> In the evening the city was entertained with Mr. Mason's Triumphal Car, in which was a portrait of general Washington, with those of count Rochambeau and General Gates,—The car was preceded by music, and a number of boys and girls, dressed in white, carrying torches.[4]

1. English poet Robert Southey under the *nom de plume* Don Manuel Espriella, in *Letters from England* (London, 1806), quoted in E. A. Standen, "English Washing Furnitures," *Metropolitan Museum of Art Bulletin* XXIII (November, 1964), 123.

2. Quoted in F. Montgomery, *Printed Textiles: English and American Cottons and Linens, 1700–1850* (New York, 1970), 279.

3. *Ibid.*, 281. Nancy Shippen quotes her relative in *Nancy Shippen: Her Journal Book* (reprint Philadelphia, 1935).

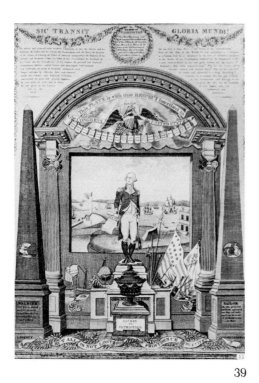

39

4. Quoted in C. C. Sellers, "Charles Willson Peale with Patron and Populace," 19, S40.

39. Attributed to **Colin Gillespie.** Scottish, 19th century

Washington Memorial Kerchief: *Sic TRANSIT—GLORIA MUNDI!*
Copperplate-printed cotton. 26 x 18¾ in. (66.1 x 47.6 cm.)
Inscribed at lower left: *Printed and Published at Glasgow by C.G. 1819;* at upper left: *SIC TRANSIT/ He united and adorned many excellent Characters, at once the Patriot and the/ Politician; the Soldier and the Citizen; the Husbandman and the Hero; the Favorite/of the genius of Liberty; the Father of American Independence; the Promoter of her/extensive and Brotherly Union; the Pillar of her Constitution; the President of/her Senate and the Generalissimo of her Armies: He possessed and dis-played/ extraordinary Abilities, exalted Virtues, and unexampled Self-Command/ and Self-Denial; moderate in Prosperity, un-daunted amid/Danger, unbroken by Adversity, firm and unmoved/amidst the Violence and Reproach of Faction,/ unper-verted by great and general Applause—/ He was great in Arts and in Arms—/ He was great in the Council/ and in the/Field.!;* within wreath at top center: *In/MEMORY OF/WASHINGTON./ This most illustrious and/Much Lamented Patriot Died on the/ 15th: of Dec. 1799, in the 68 year of his/Age, after a short Illness of 30/hours, in the full Possession of/all his Fame, like a Chris-tian/and a Hero, Calm and Collect-/ed, without a groan or/ a Sigh;* at upper right: *GLORIA MUNDI!/ He was First in Peace, First in the Hearts of the Americans,/ First in the Eyes of the World; He was unrivalled as a Statesman/ and a Senator; and he is embalmed by the Tears of AMERICA; Entombed in the Hearts of his Countrymen; admired by the Enlightened of all Lands; Immortalized by his own great actions and the Regrets of/ Mankind—why doth America weep? Why are her Courts and her/Churches covered with funeral Black? Why are her Sons Clad/in Sable and appointed to a long Mourning?—Senator! It is because He who gave Stability/ to our Constitution and Energy to our Councils. He, who was the guardian/of our Rights and our/Liberties is now/withdrawn;* within architectural vault: *this PLATE is with due RESPECT Inscribed to/the CONGRESS—of—the UNITED STATES;* upon banderole held by Eagle: *TENASEE — GEORGIA — SOUTH CAROLINA — KENTUCKY — VIRGINIA — MARYLAND — DELAWARE — PENNSYLVANIA — NEW JERSEY — NEW YORK — CON-NECTICUT — RHODE ISLAND — MASSACHUSETTS — and MAINE — NEW HAMPSHIRE — OHIO — INDIANA — MISSISSIPPI — VERMONT;* upon scroll in Washington's right hand: *FRIENDS AND FELLOW CITIZENS;* upon sculpture pedastal at center: *GEO WASHINGTON/SACRED TO PA-TRIOTISM;* upon obelisk at left: *SOLDIER/And how we admired/must we no more/behold Him who led us forth to Victory/and to glory/ LIBERTY;* upon obelisk at right: *SAILOR/ He who protected/our Trade and moved/our Navy and made/our Ports the resort/of the World is now/no More/ INDEPEND-*

ENCE; upon banderole at bottom: *BUT ALL IS NOT LOST FOR PROVIDENCE SURVIVES*
The New York Historical Society, New York City. Gift of Mrs. J. Insley Blair, 1942
LITERATURE
"Washington Historical Kerchiefs: Based on Material Gathered by Edwin Lefèvre," *Antiques* XXXVI (July, 1949), 17, fig. 9

40. **John Maclie, and Company.** Scottish, 19th century

Washington Memorial Kerchief: "And take Him All in All, We Scarce Shall Look Upon his Like Again."
Copperplate-printed cotton. 25½ x 23 in. (64.7 x 58.4 cm.)
Inscribed at upper left: *Marquis de Chastellux, Minister from the Court of France: said of this great Man/ "Brave without Temerity. Laborious without Ambition. Generous/ "Without Prodigality. Virtuous without Severity. And at the end/"of a Civil War (as at the End of Such a Life) He had nothing/ "Wherewith to reproach Himself!!!/Col. Humphries the Poet, & His Secretary, writes of His private Conduct:/ "I never saw Him divest Himself of the coolness by which he is Characterized,/ "but in Speaking of the divisions of his Country: he was ready to sacrifice repose/ "and collecting all the Friends of Liberty/ "around one Central Point: gave "Energy to Government."/ His own Words were—/ "There is no Happiness lone/ "in the Grandeur and the/ "Tumults of/"Life.";* within sunburst at center: *SACRED/TO THE MEMORY/OF THE LATE GREAT &*

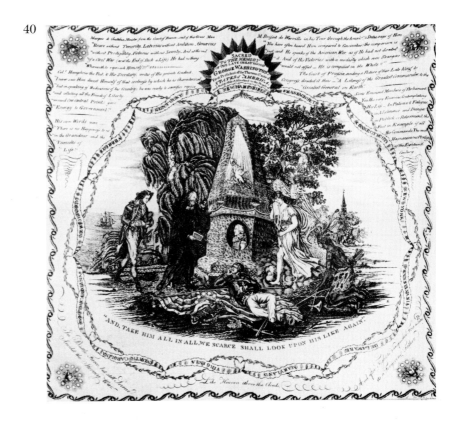

GOOD/GEORGE WASHINGTON, First President of the Thirteen United/STATES of AMERICA,/ and Respectfully Addressed to the People of; upon banderole surround: *NEW HAMPSHIRE — MASSACHUSETTS — CONNECTICUT — NEW YORK — PENNSYLVANIA — DELAWARE — MARYLAND — VIRGINIA — NORTH CAROLINA — SOUTH CAROLINA — NEW JERSEY — GEORGIA — KENTUCKY;* at upper right: *M. Brissot de Warville in his tour through the American States, says of Him/ "You have often heard Him compared to Cincinnatus; the comparison is/ "Just: and He speaks of the American War as if he had not directed/ "it. And of His Victories with a modesty which even Strangers/"would not affect—He is compleat in the Whole!!"—/ The Court of Prussia, sending a Picture of their Late King to/ Congress directed it thus—"A Likeness of the Greatest Commander to the/"Greatest General on Earth."/ Some Eminent Members of Parliament,/Yea. His very Enemies. Contemplating/ His Life—In Patience & Fatigue./ in Abstinence and Danger./ in Publick or Retirement. the/First in Example. of all/ His Commands. The Most Magnanimous Prodigy of the Eighteenth Century;* at bottom: *In Battle Fierce. but Still Serene/Amidst the Stormy Wars.—Like Heaven above the Clouds—and after Fight to Vanquished Foes as kind/ as a Forgiving Father;* upon tomb at center: *BORN/1732 / FIRST / IN / WAR / FIRST / IN / PEACE / FIRST / IN / FAME — DIED / 1799 / FIRST / IN / VIRTUE;* beneath vignette at center: *"AND, TAKE HIM ALL IN ALL, WE SCARCE SHALL LOOK UPON HIS LIKE AGAIN.*

The New York Historical Society, New York City. Gift of Mrs. J. Insley Blair, 1941.

LITERATURE
"Washington Historical Kerchiefs: Based on Material Gathered by Edwin Lefèvre," *Antiques* XXXVI (July, 1949), 17, fig. 7

CERAMICS

41. English (Liverpool), early 19th century

Pitcher: *Washington in Glory: America in Tears*
Creamware with transfer print. Height: 9¼ in. (23.5 cm.)
Inscribed at top in banner: *WASHINGTON IN GLORY;* at bottom: *AMERICA IN TEARS;* upon tomb plaque at center: *GEORGE WASHINGTON/ Born Feby. 11, 1732/ Died Decr. 14, 1799;* reverse: *WET* /[William and Elizabeth Tallman]

Old Sturbridge Village, Sturbridge, Massachusetts

PROVENANCE
Captain Elkanah Tallman; to William and Elizabeth Tallman, New Bedford, Massachusetts; to Old Sturbridge Village, 1976
EXHIBITION
Sturbridge, Massachusetts, Old Sturbridge Village, *In Praise of the Nation*, 1976
LITERATURE
R. W. Bingham, "George Washington in Liverpool Ware," *Antiques* 12 (July, 1927): 34–35, figs. 5, 7; K. E. Melder, *The Village and the Nation* (Sturbridge, Massachusetts, 1976), 33

The design for this pitcher was taken from an American engraving by James Akin and William Harrison, Jr., entitled *America Lamenting her Loss at the Tomb of General Washington,* 1800 (see 9).

42. English (Liverpool), for the American market

Pitcher: *Apotheosis of Washington.* Early 19th century
Creamware with transfer print. 10¼ in. (25.9 cm.)
Inscribed in banner at bottom: *APOTHEOSIS*
Marblehead Historical Society, Marblehead, Massachusetts

LITERATURE
R. W. Bingham, "George Washington in Liverpool Ware," *Antiques* 12 (July, 1927), 33

43. **Enoch Wood.** Staffordshire Potters. English, 19th century

Teapot: *Washington Standing at his Tomb, Scroll in Hand.* c. 1820–40
Porcelain. Height 7 in. (17.8 cm.); diameter 7 in. (17.8 cm.)

41

42

43

The New York Historical Society, New York City. Gift of Dr. Arthur Merritt, 1961

LITERATURE
D. Arman and L. Arman, *Historical Staffordshire: An Illustrated Checklist* (Danville, Va., 1974), 82, no. 191

KEY TO ABBREVIATIONS

Baker	Baker, W. S. *The Engraved Portraits of Washington*. Philadelphia, 1880.
Barck	Barck, D. C. "Proposed Memorials to Washington in New York City, 1802–1847." *The New York Historical Society Quarterly Bulletin* 15 (October, 1931), 79–90.
Brown University	Brown University, Department of Art. *The Classical Spirit in American Portraiture*. Catalogue of an exhibition at Bell Gallery, Brown University (Providence, 1976).
Deutsch	Deutsch, D. "Washington Memorial Prints." *Antiques* 111 (February, 1977).
Dreppard	Dreppard, C. W. *Early American Prints*. New York, 1930.
Dunlap	Dunlap, W. A. *History of the Rise and Progress of the Arts of Design in the United States*. 3 vols. Ed., with additions, by F. W. Bayley and C. E. Goodspeed. Boston, 1918.
Fielding *Supplement*	Fielding, M. *American Engravers Upon Copper and Steel: A Supplement to David McNeely Stauffer's American Engravers*. Philadelphia, 1917.
Hart	Hart, C. H. *Catalogue of the Engraved Portraits of Washington*. New York, 1904.
Jacobs	Jacobs, P. L. "John James Barralet and the Apotheosis of George Washington." *Winterthur Portfolio* 12 (1977), 115–37.
Jaffe	Jaffe, I. B. *John Trumbull: Patriot-Artist of the American Revolution*. Boston, 1975.
Morgan and Fielding	Morgan, J. H. and Fielding, M. *The Life Portraits of Washington and their Replicas*. Philadelphia, 1931.
New York, 1976	New York, Fraunces Tavern Museum. *The Many Faces of George Washington*. 1976.
NPG *Illustrated Checklist*	National Portrait Gallery, Smithsonian Institution. *Illustrated Checklist of the Permanent Collection*. Washington, D.C., 1978.
Providence, 1976	Providence, Rhode Island. Brown University, Department of Art. *The Classical Spirit in American Portraiture*. 1976.
Schorsch	Schorsch, A. "Mourning Art: A Neoclassical Tradition in America." *The American Art Journal* VIII (May, 1976), 4–15.

Sellers, "Charles Willson Peale with Patron and Populace"

Sellers, C. C. "Charles Willson Peale with Patron and Populace: A Supplement to Portraits and Miniatures by Charles Willson Peale." *Transactions of the American Philosophical Society* 59. Part 3. May, 1969.

Sizer

Sizer, T. *The Works of Colonel John Trumbull, Artist of the American Revolution.* New Haven and London, 1967.

Stauffer

Stauffer, D. M. *American Engravers Upon Copper and Steel.* 2 vols. New York, 1907.

Stokes, *Iconography*

Stokes, I. N. P. *Iconography of Manhattan Island, 1498–1909.* 6 vols. New York, 1916.

Taylor

Taylor, J. C. *America As Art.* Catalogue of an exhibition at the National Collection of Fine Arts, Smithsonian Institution. Washington, D.C., 1976.

Thistlethwaite

Thistlethwaite, M. *The Image of George Washington: Studies in Mid-Nineteenth-Century American History Painting.* University of Pennsylvania Ph.D. thesis, 1977.

Washington, D.C., 1976

Washington, D.C., National Collection of Fine Arts, Smithsonian Institution. *America As Art.* 1976.

Whittemore

Whittemore, F. D. *George Washington in Sculpture.* Boston, 1933.

Selected Bibliography

These items reflect general sources for the study of the iconography of George Washington and apotheosis. Not included are bibliographical references in the catalogue of the exhibition and the introductory essay, both of which include complete citations of sources used in those sections.

Allen, I. "Providential Events in the Life of Washington." In *Washington's Birthday*. Ed. by R. H. Schauffer. New York, 1932.

Baker, P. *The Fortunate Pilgrims: Americans in Italy, 1800–1860.* Cambridge, 1964.

Barker, V. "Colloquial History Painting." *Art in America* 42 (May, 1954), 118–25, 156.

Bryan, W. A. "Minor Washingtoniana." *Tyler's Quarterly Historical & Geneological Magazine* XXV (January, 1944), 164–70.

Carroll, J. L. *The Sages & Heroes of the American Revolution.* Philadelphia, 1851. Port Washington, New York, 1970.

Commager, H. S. "The Search for a Useable Past." *American Heritage* XVI (February, 1965), 4–7.

Crawford, J. S. "The Classical Tradition in American Sculpture: Structure and Surface." *American Art Journal* XI (July, 1979): 38–52.

Dreppard, C. L. "American Drawing Books." *Bulletin of the New York Public Library* 49 (November, 1945), 795–811.

Eulogies and Orations on the Life and Death of General George Washington. . . . Boston, 1800.

Fogg Museum, Harvard University. *Washington, Lafayette, and Franklin.* Cambridge, Massachusetts, 1944.

Ford, P. L. *Washington and the Theatre.* New York, 1899.

Grolier Club, New York. *Exhibition of engraved portraits of Washington commemorative of the centenary of his death. December 14, 1899–January 6, 1900.* New York, 1899.

Hofland, T. R. "The Fine Arts in the U.S., with a Sketch of Their Present and Past History in Europe," *The Knickerbocker* 14 (July, 1839), 39–52.

Holden, O. *Sacred Dirges, hymns, and anthems, commemorative of the death of Gen. George Washington.* 2d issue. Boston, 1800.

Hough, F. B. *Washingtoniana, or Memorials of the death of Washington . . . The funeral honors paid to his memory, with a list of tracts and volumes printed upon the occasion, and a catalogue of medals commemorating the event. . . .* 2 vols. Roxbury, Massachusetts, 1865.

Howard, J. T. *The Music of George Washington's Time.* U.S George Washington Bicentennial Commission: Washington, D.C., 1931.

Marzio, P.C. "The Forms of a Democratic Art." *Papers on American Art.* Ed. by John C. Milley. Maple Shade, New Jersey, 1976.

McCarty, W. *Songs, Odes, and Other Poems on National Subjects,* 3 vols. Philadelphia, 1842.

McCorker, J. "Philadelphia's Printmaking Tradition." *Philadelphia Forum* XXXI (1952), 6–7.

McCormack, R. P. "Washington as a Hero." *Reports and Abstracts of Proceedings of the Annual Meeting of the Washington Association of New Jersey* (February 22, 1969), 17–28.

McRae, S. *Washington: His Person as Represented by the Artists.* Richmond, Virginia, 1873.

Miller, P. "The Garden of Eden and the Deacon's Meadow: The Old Testament's Strong Influence on 18th Century America." *American Heritage* VII (December, 1955), 54–61.

Misener, G. "Iconistic Portraits." *Classical Philology* 19 (1924), 97–123.

Mitchell, C. "Benjamin West's 'Death of General Wolfe,' and the Popular History Piece." *Journal of the Warburg and Courtauld Institutes* 7 (1944), 20–33.

Murdock, M. C. *Constantino Brumidi: Michelangelo of the U.S. Capitol.* Washington, 1950.

Nourse, J. D. *Remarks on the Past and its Legacies to American Society.* Louisville, 1847.

Orme, E. *An Essay on Transparent Prints, and on Transparencies in General.* London, 1807.

Rosenblum, R. *Transformations in Late Eighteenth-Century Art.* 1967. Reprint, Princeton, 1970.

Rowland, B. *The Classical Tradition in Western Art.* Cambridge, Massachusetts, 1963.

Sellers, C. C. *The Artist of the Revolution: The Early Life of Charles Willson Peale.* Hebron, Connecticut, 1932.

Sellin, D. "Denis A. Volozan, Philadelphia Neoclassicist." *Winterthur Portfolio* 4 (1965), 119–28.

Schorsch, A. *Mourning Becomes America.* Harrisburg, Pennsylvania, 1976.

Smyth, A. H. *The Philadelphia Magazines and Their Contributors, 1741–1850.* Philadelphia, 1892.

Sommer, F. "Emblem and Device: The Origin of the Great Seal of the United States." *The Art Quarterly* XXIV (Spring, 1961), 57–76.

Stillwell, M. B. *Washington Eulogies: A Checklist.* New York, 1916.

Taylor, J. C. "The Religious Impulse in American Art." *Papers on American Art.* Ed. by John C. Milley. Maple Shade, New Jersey, 1976.

Taylor, L. R. *The Divinity of the Roman Emperor.* Middletown, Connecticut, 1931.

Vermeule, C. "Neoclassic Sculpture in America: Greco-Roman Sources and their Results." *Antiques* 108 (November, 1975): 972–81.

Wecter, D. *The Hero in America: A Chronicle of Hero-Worship.* New York, 1941.

Weems, M. L. *The Life of Washington.* Ed. by Marcus Cunliffe. Cambridge, Massachusetts, 1962.

Williams, W. *Transparency Painting on Linen; for Decorative Effects, Ornamental Blinds, etc., With Instructions for the Preparation of the Linen, the Combination and Transfer of Ornamental Designs, Combined surfaces, etc.* London, 1856.

Wind, E. "The Revolution in History Painting." *Journal of the Warburg and Courtauld Institutes* II (1938), 116–27.

Wroth, L.C. *An American Bookshelf, 1775.* Philadelphia, 1934.

Museum Visiting Committee

Mrs. Priscilla Cunningham '58, *Chairman*
David S. Brooke
Mrs. Leonard Brown
Charles E. Buckley
Mrs. Malcolm G. Chace, Jr. (Beatrice Oenslager '28)
Mrs. Jerome Cohen (Joan Lebold '54)
Professor Colin Eisler
Selma Erving '27
Mrs. John R. Jakobson (Barbara Petchesky '54)
C. Douglas Lewis, Jr.
Dorothy C. Miller '25
Elizabeth Mongan
Mrs. John W. O'Boyle (Nancy Millar '52)
Mrs. James E. Pollack (Mable S. Brown '27)
Morton I. Sosland
Mrs. Morton I. Sosland (Estelle Glatt '46)
Mrs. Alfred R. Stern
Mrs. Charles Lincoln Taylor
 (Margaret R. Goldthwait '21)
Enid S. Winslow (Enid Silver '54)
Mrs. John Wintersteen (Beatrice McIlhenny '25)

Staff of the Museum

Charles Chetham, Director, Chief Curator
Betsy B. Jones, Associate Director, Curator of Paintings
Inga Christine Swenson, Acting Assistant Curator of
 Prints and Drawings
Linda D. Muehlig, Curatorial Assistant
Kathryn Woo, Assistant for Administration
Gwen Gugell, Acting Registrar
David Dempsey, Preparator
Patricia Anderson, NEA Intern
Michael Goodison, NEA Intern
Constance D. Ellis, Assistant for Publicity and Events
Jean Mair, Archivist
Wilda Craig, Receptionist and Membership Secretary
Janice St. Laurence, Receptionist